Crimeways

Crimeways

edited by Rita McBride and Matthew Licht

Arsenal Pulp Press, Vancouver
Whitney Museum of American Art, New York
Printed Matter, Inc., New York

CRIMEWAYS
Stories copyright © 2005 by the authors

ARSENAL PULP PRESS
341 Water Street, Suite 200
Vancouver, B.C.
Canada V6B 1B8
arsenalpulp.com

Cover photograph by Glen Rubsamen
Cover and interior design by David Gray
Printed and bound in Canada

This is a work of fiction. Any resemblance of characters to persons either living or deceased is purely coincidental.

Library and Archives Canada Cataloguing in Publication
 Crimeways / edited by Rita McBride and Matthew Licht.
Co-published by: Whitney Museum of American Art, Printed Matter Inc.
ISBN 1-55152-173-3
 I. McBride, Rita, 1960- II. Licht, Matthew, 1960- III. Whitney
Museum of American Art IV. Printed Matter Inc.
PS8600.C74 2005 C813'.6
C2005-900971-3

This project is a co-publication between Arsenal Pulp Press, the Whitney Museum of American Art, and Printed Matter, Inc.

ARSENAL PULP PRESS
341 Water Street, Suite 200, Vancouver, BC, Canada, V6B 1B8
arsenalpulp.com
Arsenal Pulp Press gratefully acknowledges the support of the Canada Council for the Arts and the British Columbia Arts Council for its publishing program, and the Government of Canada through the Book Publishing Industry Development Program for its publishing activities.

WHITNEY MUSEUM OF AMERICAN ART
945 Madison Avenue, New York, NY 10021, USA
whitney.org
The Whitney Museum of American Art is the leading institution of twentieth- and twenty-first-century American art and culture. An essential forum for American artists since its founding in 1930, the Whitney's goal is to champion freedom of artistic expression and to foster the development of art in America.

PRINTED MATTER, INC.
535 West 22nd Street, New York, NY 10011, USA
printedmatter.org
Printed Matter, Inc. is an independent 501(c)(3) non-profit organization founded in 1976 by artists and art workers with the mission to foster the appreciation, dissemination, and understanding of artists' publications. Printed Matter's Publishing Program for Emerging Artists was made possible through the generous support of New York City's Department of Cultural Affairs. Additional support has also been provided by the New York State Council on the Arts.

Contents

Joe Morocco

Maybe it was the real deal, maybe nothing at all. It seemed to come from far off, but then you never know anymore. Things have gotten to the point where a car backfiring sets off the question marks in people's eyes, and sends them combing the radio news channels the way a pill-popper pores over the pages of his PDR.

Add that to a bad month, with the rent coming due. Rain all week, then it stopped and the sun came out just in time to set. I poured myself the last of the bourbon, and as I looked out my office window the light was pure gold, reflecting everywhere. And if it weren't for that old woman across the street, the one with *It's a Small World After All* tattooed across her face in seven different languages, the one who's there day after day scraping the gum off the sidewalk. . . . Well, if it weren't for her and, say, Mrs Negretti, the down-at-the-heels spiritualist one door over, who just now started screaming that the little men on her tarot cards have come loose and are robbing her blind. . . . Well, if it weren't for things like that, with the sun reflecting off all the rain-wet buildings and the gutters running full as the River Jordan, one might be put in mind of the Golden City of God, like in Revelations.

That's when she walked into my office. She was a blonde, the sort with roots that coffee-with-skim-milk kind of color. She was a pure-D pleasure to behold, with legs that came all the way up to here, and then some. When she sat down and crossed them, one knee sliding over the other, she left me lost in a world of sighing nylon. Or maybe it was just the rush of blood she sent flooding through my skull. "Don't tell me I missed last call, Mr Morocco," she husked, eyeing the empty bottle on my desk like a hound staring down a Denver omelet. "That'd be just the topper to a rotten day."

I pushed the glass over to her side of the desk. "What can I do for you, Miss –"

"Mrs Cley. Romanza Cley. It's about some rather threatening phone calls we've been receiving. Frankly, I'm at my wits' end."

She didn't look remotely like someone at her wits' end. "Why not go to the cops?"

"That might prove embarrassing. Look, if you're free, perhaps we could drive out to the house. My car is waiting, and if I'm away too long Mandible gets upset."

"Mandible?"

"Mandible Cley. My husband." There are dames who will refer to their spouses as "my husband" as often as possible, like it marks their piece of turf in the world. Romanza, on the other hand, practically gagged on the words.

The driver was a tall thin job with a kisser like one of those painted masks you used to see in Kon Tiki rooms. The limo moved about as fast as a Third World economy. If it hadn't been for the shaker of cocktails waiting on ice I might have complained. On the way, Romanza refused

to discuss the case, and instead leaned back to stretch and rub against the upholstery as she launched into a whole other topic.

"I'm so tired I'd like to have somebody carry me home, put me to bed . . . and feed my cat." She gave me the once-over, slow. "And my cat hasn't been fed in weeks."

"Sounds like you're looking for somebody who doesn't mind a few scratches." I took a sip from my drink – a big one.

"You look like you could handle the job. All you need is a friendly hand and a warm lap." She shot me a smile like an X-rated toothpaste ad.

Maybe it was the liquor, maybe it was the sound of her voice. Or maybe it was the way her hand kept patting my leg for emphasis, each time getting closer to pay dirt, till I was hardpacked and bouncing around like a pogo stick.

"This cat got a name?" I asked, just for something to say.

"Trivet. On account of she's only got three legs." She ran a tongue over her perfect choppers. "She had four, but she lost one."

"Sounds careless."

"Sometimes three legs is all you need." She gripped me through my pants leg, right at the root. "Let's just say she's had a full life. Only problem is, she tends to tear up the furniture if she doesn't get attention on a regular basis."

"Ever think of having her declawed?" I asked.

"Oh, she needs those, the places she goes. She's been known to hang out in alleys."

Casa de Cley was one of those mausoleums built around the turn of the century – the century before last – the kind that got popular for converting into embassies, or private hospitals where the well-heeled can quietly lose their marbles. It was located up in the East Sixties, right on the water, with a foyer so big it made you wish you'd packed a saddle pony. Romanza pointed out a door in the distant haze, then disappeared.

Hubby was waiting there in the study, a gloomy room with an odor that made my skin crawl. He was the kind of old geezer who's all soft gut, with a too-large head and limbs like matchsticks. He scuttled toward me, his tiny shoes clicking across the marble.

"Ah! My wife's – what shall I call you? Gumshoe? Shamus? Private Dick?"

"Try Morocco. What's the smell?"

"Ambrosial, isn't it?" He gestured toward the walls. They were covered in shadow boxes filled with insects, thousands of them. "I can't tell you the pleasure I take in my art. The hunt, the killing jar, the sweet scent of death as I mount the display." He moved close, too close. "The satisfying crunch of pin piercing thorax." He put his hand over mine. It had the feel of a really fine alligator wallet: cold, rough and expensive. "What do you make of my wife? I must admit, I find her something of an enigma of late. A little hard to read, don't you find?"

I shook his hand loose, I was taking a chill. "I read her like a book, one that keeps falling open to the same spot." His stare turned icy. "Don't get me wrong, I like a book that's a little dog-eared. Shows it's worth perusing. Problem is, right now I'm missing a few chapters. Your

wife tells me you've been getting some troublesome phone calls?"

He seemed to ponder this with increasing amusement. "Hmmm . . . it seems so. The strange thing is, no one has intercepted these calls except Romanza herself. Now I ask you, Mr Morocco, what can you do with a girl like that? Let's see, did she describe the caller's voice as Russian, or was it Middle Eastern? I do recall that the gist was of a threatening nature, something to do with an upcoming event I'm to attend, at AMNH. To tell you the truth, I forget quite how it goes. It's like one of those popular songs my wife likes: I can remember the coarse little tune, but the lyrics escape me."

"And you have a suspicious nature. What does AMNH stand for, anyway?"

"American Museum of Natural History. I wonder if a virile specimen like yourself can grasp the impact it's had in my life. You see, I was what is politely termed a bookish child – in other words, a pariah. Needless to say, my cerebral fascinations were not shared by my grunting, sweating classmates, with whom I shared a relationship of mutual disgust. Yes, the torments of the football field, the spermy stink of the gym mats, the shower room pranksters. . . . But then I'm sure you're familiar with the well-documented innocence of childhood." He paused to peer at me as if from a great distance. In fact, I could just about imagine the sort of locker-room eunuch figure Mandible must have presented; as an adolescent target, he would have proved irresistible.

"One afternoon, I was fleeing homeward across the park. Prodded with sticks, pursued by pubescent demons, I took refuge in the perfectly ordered world of

the museum." His eyes retreated into their sockets, leaving a faraway look, like time was suddenly facing the other direction. "I'll never forget the muggy afternoon I first entered those sanctified depths, inhaled the dusty chill. Suddenly I found myself surrounded by the wonderland of segmented, invertebrate beasties in all their seductive beauty. No longer the odd boy out, I'd found sanctuary. It's only fitting that I give something back."

"Meaning what?"

"Two nights from now the museum is honoring me with a gala reception. Of course, the real reason I'm being fêted in this fashion is that I'll be presenting them with the bulk of my estate, the most prodigious donation on record, a move designed to secure a home for all this" – he gestured around at the walls – "my life's work. As a matter of fact, my important collections have already been transferred. But I'm not losing a fortune, Mr Morocco, I'm gaining a masterwork, the most beguiling art masterpiece in all New York." His voice became a greedy whisper. "For all intents and purposes, my largesse will merge Manhattan's finest creation with myself. Yes, the museum and I will become one. A hybrid if you will."

"Where does the wife fit into all this?"

He snorted with bemusement. "Romanza doesn't grasp the importance of my achievements. To my wife it's money wasted on something other than her. I think she'd do just about anything to discourage my plans."

"So it's your hunch that Mrs Cley is behind these threats?"

"Frankly, I think my wife's a liar. Not that I mind . . . it's one of the least offensive of her many earthy charms." He took a step closer; I took one back. "A word of advice,

Mr Morocco. Remember who you're working for. In other words, don't get too close to your subject, I wouldn't like to have to reprimand you."

He held out a cheque. It was big enough to hook me, and small enough to keep me coming back for more. "What's this buy?" I asked, folding it into my wallet. "You better lay it out for me, chapter and verse."

"Information. Romanza hangs at a critical point, Mr Morocco. Metamorphosis is in the air. The chrysalis has begun to twitch, and it's imperative that I know what will emerge. Be in touch. Bye-bye!"

Romanza surfaced again as I searched for the front door. As we shook goodbye, I felt her slipping me something. Outside, wind was whipping over the East River. Off to my left I could just make out a helicopter in the shadows of the vast terrace, drowsing on its landing pad like a giant dragonfly sleeping one off.

Under the swinging lamp of the *porte cochère*, I undid my fist to find a book of matches. The cover carried a single word printed out in circus letters: ABRA-CADABRA, with a time penciled inside. Looked like we'd be meeting again the next day around lunchtime.

The Abracadabra was a long-forgotten joint down where Chinatown used to be called Little Italy. I took a booth in back at the appointed hour. Like any dame worth her salt, she kept me waiting. Thirty minutes and two shots later, she showed up. Her nylons husked a siren's song as she strutted toward me on stiletto heels. She claimed someone had been following her car, and she'd spent the last half hour shaking her tail. I told her I wished I had been there to see it. She gave that one a slow pass.

I ordered drinks and kept 'em coming. The third round put her in a talking mood. "Look, I'm gonna tell you something I've never told anyone. I was born out west in a flophouse over a bar that featured what's politely termed 'exotic entertainment.' By the time I was thirteen I was headlining at the club downstairs. That's where I met Cley. He'd been down in Baja collecting specimens. I guess he had room for one more. Eventually, he asked me to marry him."

"So it was apple blossom time?"

"Poverty has a stink of its own. I would have done anything to get down off that stage. He brought me here, to his bug museum. I wouldn't say I'm exactly crazy about the arrangement."

"Why tell me all this?"

"What do I have to do, wrap myself up like a Christmas present and mail myself to your bedroom?"

"Where does Hubby fit in? You gonna let him lick the stamps?"

"He's a pig. And I don't like pigs."

"Not even if they're in the chips?"

"Not even in blankets – with maple syrup."

"If the accommodations don't suit you, why not check out?"

"My husband's a powerful man when he wants to be – money does that. He'll never let me go as long as he's alive, he's spelled it out in so many words. Besides, thanks to the pre-nup I don't score a plugged nickel if I walk out on that porker . . . before he kicks."

"That must be galling, to say the least. Unless. . . ." I wanted to see where she'd run with that.

Romanza gave me a sidelong look then, like she was

mulling it over. Then she turned on me with those big brown eyes. "Don't worry about me, I always get my licks in."

I knew I should just get the hell out of there. Thing was, I couldn't remember how to walk. I ordered one more for the road. Romanza looked at her watch and said she had an errand to run. I staggered out after her, and joined her in the limo's back seat.

As soon as the car left the curb, she flung herself back against the upholstery and launched into her favorite topic. "Ye gods, I'm exhausted. That damn cat again, howling on the back fence all night. And I'm a wreck if I'm not prone for a good eight hours."

"Eight hours at a stretch, or cumulatively?" Somehow I couldn't seem to help asking.

"Eight hours flat on my back with my fingers clawing the mattress and the pictures falling off the walls."

This time she didn't pat my leg for emphasis, just slid right to home base. She kneaded me through my trousers the way a milking machine works a cow's moneymakers. Then, just in case I hadn't gotten the message, Romanza opened my fly, climbed on facing me, and made herself comfortable. She was definitely a take-charge type, and kept my hands pinned against the seat back. Her long, cool fingers bit into my wrists, with a grip like a pair of cuffs. She was surprisingly strong for a dame – not that I put up much of a struggle.

As the skin-tight skirt of her suit hitched a ride north, I savored the view. In addition to the garter belt and hosiery, she had on the type of underwear you see for sale in upscale sex shops, the kind with an open slit running down the center strip. And her panties weren't the

only thing spread and wet. She clamped on tight, and the way she rode me made it clear I wouldn't need to worry about whether it was good for her, too – taking care of numero uno was Romanza's first order of business. There was nothing for me to do but lean back and enjoy the ride. By the time we reached the thirties, we were both hitting the finish line, and as we passed through that tunnel that runs through what I still think of as the Pan Am Building, I caught the driver's reflection in the windshield glass. You would have sworn he hadn't noticed a thing, if it hadn't been for the Adam's apple riding up and down his gullet faster than the only elevator in an eight-story cathouse.

Traffic had come to a standstill, and I got out to check. There was a roadblock ahead, and I walked on up to see what I could find out. Apparently someone had left a suspiciously motionless paper bag on the sidewalk, and the cops had stopped traffic till the bomb squad could check it out.

When I got back to the car, no one was manning the driver's seat. As I stuck my head through the window, I heard what sounded like the hyperventilation of a cornered animal. Romanza was lazed back on the seat, her skirt around her waist. Meanwhile, the chauffeur was kneeling with his face buried in the darkness between her legs. Tongue unfurled, he was licking up the last of the leftovers like a moth gorging on midnight nectar. Judging from the pitch of Romanza's grunts, he must have been doing a first-class job. She finally released his head from her unclenching thighs, and he raised his shiny-chinned face in what could only be described as exultation – if you felt the need to

put a label on it. I decided to catch the subway back downtown. Fortunately, mine was one of the few lines still running.

Back at the office, there was that old tattooed woman again. She'd been working her way up the stairs, and had finally reached my landing. The way she scrubbed her way up to my door gave me the feeling she had something she wanted to get off her chest. She sat back on her haunches and pointed out a tattoo between her clavicles. It was the sun, like a kid might draw it. A circle with rays, all in black. Then she began to hiss and snap her teeth. I thanked her for the gander, hopped into my office, and locked the door behind me. Inside, someone was waiting. He got my attention with a not-so-subtle tap to the back of my head.

I came to, feeling beat as a Baptist stepchild, tied to a chair in a world where a pencil was just as likely to roll uphill as down. There was that smell again, like something cold and bitter. Hubby was splashing about in a marble tub, wearing a big pair of candy-striped trunks that came up to his dimpled armpits. When he noticed me shifting in the chair, trying to work some blood back into my tightly bound limbs, he emerged and slipped into a terrycloth robe and slippers.

"Pardon my appearance, Mr Morocco. My skin finds relief in the waters." He paced back and forth, leaving a wet trail. His mouth made juicy clicking noises. It must have been dentures, but when I looked at him through my still-hazed vision, I could have sworn he was scissoring his jaw from side to side. He stopped moving and stood before a work table covered with bugs. He pointed out one in particular.

"Ah, behold the fair tarantula wasp. An ethereal beauty, yet left to her own devices she sets up housekeeping in a hole in the ground and stocks her larder with that most virile of spiders, the hairy tarantula."

"Guess she's like most of us – she likes what she likes."

He let that pass. "Yet even in death, she cuts an elegant figure, with her slender waist, her audacious bearing, her uncouth appetites. Tell me, Mr Morocco, how are you and my wife getting along?"

"I've got no complaints."

Hubby really worked his mandibles over that one. The dark juice that oozed from the corner of his mouth made me hope he was chewing tobacco. "What's she up to, Morocco?" He was right in my face, and I didn't like it.

"Why not ask her?"

"I wouldn't like to think you've changed sides, Mr Morocco. Rumor has it you've been taking liberties."

"I'm as red-blooded as the next guy – present company excepted."

That one earned me a slap. "I'll pay you twice what my wife offered if you tell me what she's up to."

"What makes you think you've got what your wife offered?"

He gave me another slap of alligator hide. This one knocked my hat off.

"I don't know what I might do if I thought someone was planning to deprive me of her beauty." He slammed his palm down on the table. A jar fell and shattered on the floor; bugs ran in all directions. "Why, if I thought someone was trying to take her away from me. . . ." He stomped his tiny foot, squashing a particularly large, wet

Joe Morocco

beetle. "I'd have no more compunction in dealing with such an individual than I would in crushing the lowliest cellar-floor vermin." He cleaned his sole on my fedora. "You see, such a death is insignificant, and the heel of a slipper is so easily wiped off. My, my, I hope you don't end up like that. That would be a pity."

"I must admit to harboring somewhat grander hopes as well." I was only half-kidding.

"Romanza is a woman of strange and consuming appetites – and I'm a jealous spouse. So you see, you have the devil on one side, the deep blue sea on the other." The sound that came out of him then could have almost passed for laughter. "Yes, it's the frying pan or the fire, Mr Morocco. Beware." He was really breaking himself up. He gurgled until tobacco juice ran down his jowls and soaked the terry cuddling his soft chins. He came toward me with a cotton wad stinking of chemicals, and I was gone.

I came to the next day in the meat district, flat on my back in a gutter staring up at a row of hogs with eyes like Xs. One jowly number looked oddly familiar, and that's when I remembered all that had passed earlier. I started walking; no cabby in his right mind would have picked me up. By the time I got back to the office, I was straight, give or take.

Mrs Negretti, the palm reader, waylaid me on the way to my door. Her social security check had come in, and she was celebrating with a six-pack. She gave me a warm malt liquor and heated up a late lunch of leftover tamales. They were just the way I like 'em: spicy as hell, the grease running off my elbows. When she thought I'd had enough, she told me a dame had been there looking

for me, a bottle blonde with something on her mind. Three guesses. The note under my door said to drop by the house ASAP, and after a quick rinse and change of clothes I was happy to oblige.

As I exited the building, I wondered about the crowd gathered around a storefront window. They were staring at a display of televisions, all running the same story. Live footage showed assorted local reporters camped out in front of a burning building, moving their mouths in no doubt earnest reportage. Through the glass, I wouldn't have had a clue what they were talking about, if not for the text running along the bottom of some of the screens, announcing the latest devastation – this time at the Museum of Natural History.

Out at Casa de Cley, the door was unlocked and the joint seemed deserted. All was silent, save for the echoing sounds of soft music – sounded like Sinatra. I wondered if I'd been stood up and called her name. She was there, all right – all there. She walked across that foyer with nothing on but the radio, jiggling a cocktail shaker. As she came toward me with that 24-jewel movement, I didn't know whether to howl or whimper.

"Now I know how Pavlov's dogs felt. You don't happen to have a bib handy, do you?"

"Search me," she husked as she poured us a couple of tall ones. I took mine down in one potent, minty gulp. Unfortunately my stinger was a mickey – the poison was fast, I didn't even get a chance to frisk her.

I came to, heaving my cookies. I must have lost the tainted booze along with my chow, nothing like a bad tamale to clean out your system. The joint was quiet, too quiet. An uneasy sixth sense told me something was

wrong. I found Cley in his study. He must have jumped when she pulled the speargun on him – he was suspended in midair, pinned against the wall among the other insects. His heels clicked a tattoo against the glass cases in the breeze through the open French doors. I wouldn't say he was much to look at the first time I saw him, but he looked a hell of a lot worse the last time.

I heard an engine hacking to life, and ran out onto the terrace. Romanza and the tall job were on board. Maybe it's true what they say about butlers, or maybe they just live down to expectations. He was gunning the copter's motor and the blades were whipping up a storm. The last time I saw her, they were headed down the river toward the open sea.

I dropped a dime to the cops, then spent the rest of the night at the station going over my story. The way I told it, the butler did it. I made Romanza out to be a kidnap victim. I felt I owed her something – besides, no guy wants to admit he's been sapped by a skirt. About five in the morning, I must have finally got it right – they let me go.

The autopsy boys showed me the stuff in Cley's pockets: a tooth; a fossil fly in amber; and a funny little bolt, looked precision. From the serial number, it came from some sort of military craft, the local whiz kid said. That explained a lot to me later, when I saw the early editions.

Romanza's chopper had gone out of control, and crashed into the Queensboro Bridge. The picture showed it strung between the suspension wires like a dragonfly stuck to the grill of a Mac truck. Funny thing, though; only the tall thin job was on board. Romanza's body was never recovered.

I took a cab to that little park right there off Sutton Place, the one that hangs out over the highway. Part of the copter still clung to the bridge, welded in place. It was lonely out there, dawn coming on. Storm clouds were rolling off the city, and the wind was howling over the water. You get a sense of time, staring at the river, how it empties into the sea. I guess there's a time for everything, and right about then it felt like time for breakfast.

That's when the impact hit me like a punch to the gut and laid me flat on my back, staring up into a whitening sky.

Rope-a-Dope à Deux

A distant explosion interrupts an amazing fantasy I am having about a perfectly formed, wild and nimble Swedish blonde. Suddenly I am up and, sadly, alone. It's surprising how daydreams can seem so deliciously real, and how my real life beckons the imagined. My name is Glenn. I'm in my forties, a successful and insecure designer driven by a desire to fail at failing. I was named after Glenn Miller, the big band leader who in 1937 created a unique orchestral reed sound that set his band apart. My parents listened to the Moonlight Serenade radio series sponsored by Chesterfield cigarettes that aired three times a week on CBS. Mom and Pop were huge big band aficionados especially during WW II when Miller's Army Air Force band performances were broadcast live around the world on the airwaves. Glenn Miller said that he was seeking to create a band with "a sound all its own," which is what my parents impossibly hoped for me.

The explosion produces a constant stream of sirens but they seem barely more distinct than the usual background chaos in New York City. I get up and perform my ritual morning ablutions, fading in and out of a more conscious dream state, still imagining the nimble one. I

finish my activities and begin to page through the morning paper that has been delivered to my door. It is always comforting to open the front door and see the paper lying on the hallway floor, pick it up, and unfold the events of the world: to feel the thin paper, read the Gothic headlines, and be instantly engaged in the most important news of the day (or at least someone's idea of what is important). Unfortunately, the news of late has become so familiar and repetitive that our city's distressing situation now seems benign and meaningless. Stories of diminishing personal freedoms at home in the face of real or imagined terrorist threats pervade the reports. I begin to drift again and daydream about the paper itself, this antique means of communication: unrefined paper with applied ink, cut edges, comfortable smell, and images that are actually frozen the night before. No mention of the immediate. Nothing of the moment.

I'm back and now wonder what exactly the morning's explosion was. As is my habit, I refold the paper and collate the sections back together as my father always did. I head to my computer and intend to search the Internet for instant stories relating to this morning's huge, strange sound. What was it? Was it another terrorist attack or simply some kind of accident? I get distracted and click on my favorite sites relating to Formula One racing, hoping for a miracle turnaround for my favorite Williams/BMW team. They, along with all the others, trail behind Ferrari again this season. But it's not sport anymore, it's just money. Formula One racing is becoming boring and all too predictable. The teams with the most money are miles ahead. I've been a fan for years, but now I'm thinking of switching to bad-

minton, a sport that requires almost no money to be competitive.

I google to MSNBC. Someone has tried to blow up the Brooklyn Bridge! A bold attack on one of New York's great architectural landmarks. The Brooklyn Bridge was designed and constructed by John Augustus Roebling and his son, Washington Roebling, a year after James Joyce was born in 1883. It was a brilliant engineering feat spanning 1595.5 feet from Brooklyn to Manhattan. The roadbed is 135 feet above water level (about the height of the Statue of Liberty from its base to the torch), and is as wide as Fifth Avenue. Suspected terrorists set a line of plastic explosives under the roadbed in an apparent attempt to damage the critical suspension cables and the supporting braided metal strands. Thankfully, the Roeblings designed it with a cable factor of safety that is 4.1 times the actual stresses. This over-engineering is apparently why she survived the powerful blast. What the terrorists managed to destroy was a set of suspended metal-encased conduits that are not critical to the structural integrity of the span. This plot was spoiled by the terrorists' apparent incompetence and lack of cable structure knowledge. No one was hurt.

I think about bridges in the Roeblings' time. They linked us to our neighbors. Now we are virtually linked by the Internet and telephone. In the '90s, telecom companies created information highways. The telcos strung these conduits – fiber optic cables – beneath the bridge in 1997.

The experts and journalists feel that this has been an unsuccessful attack on a piece of our urban infrastructure. Another symbol attacked. Again it raises grave

concerns about security. Can our city survive more and more of these attacks and devastations? How is it that New Yorkers just carry on? Are we crazy or determined? I am really tired of this. Perhaps it is part of a diabolical plot to sever all of Manhattan's connections to the mainland. Without our relationship to others, who are we? New Yorkers know they are the epicenter. What is a center with nothing around it?

I can't even begin to imagine what it might be like to live in New York without bridges and tunnels. It might be something like John Carpenter's movie *Escape From New York*, where New York's Manhattan Island is a maximum-security prison. Snake Pliskin, a soldier of fortune, is sent in to a lawless prison to rescue the President, whose plane has crashed there. It's a mean and terrifying portrait of New York in the future.

There are only twenty-one vehicular or pedestrian connections for all of Manhattan, including three tunnels and eighteen bridges: three on the West Side, two in the north, and sixteen on the east. Surprisingly few. Is this a plot, cleverly conceived to isolate Manhattan from the boroughs? It would cause chaos, leaving millions of us stranded, trapped, and incarcerated. No *New York Times* on our doorstep.

I am seriously disturbed by the attack and decide to distract myself. I call up my friend Arnold Choncho to see if we can have lunch at Buddies. Buddies is a local hangout located near the Elite modeling agency, so it is always filled with amazing specimens. Arnold and I get a prime table near the door so we can scope out the trim as they come and go. Some of the talent is truly amazing, an instant catalyst for fantasy. The atmosphere is usually the

kind that people come to New York to be part of. But today it's tense. The anxious crowd is there to save themselves from being alone. The discussions are all about the Brooklyn Bridge. Everyone is growing tired of being afraid. Arnie and I decide to go home because the mood is strained, and it is hard to fantasize or even relax here. The streets are filled with cops and FBI guys with earpieces who are blocking streets, searching pedestrians. Behind their sunglasses they seem like automatons. A totally useless overreaction intended to show that the government has secured the city. What a sham. The reality is that the city is vulnerable to almost anything the attackers want to hurl at us. It all seems so hopeless. Museums, bridges, tall buildings, parks, all now attacked at various times, scattered plots intentionally loaded with symbolic value. Is this newest plot part of a scheme to transcend symbolism and physically isolate the island?

I arrive back at my apartment and check the Internet to see what's new. I discover that the "facts" about the explosion are transformed into many stories about devious plots conceived by another fundamentalist group. The news is written without restraint, without discipline. Net news has become so instantaneous that it is largely fiction pumped out by aggressive writers sensationalizing scenarios. Reflecting on facts is not in their repertoire. Incidents and rumor become departure points for a creative writing exercise. "Who cares?" they seem to say, if the situations become realities. The juiciest tales focus on world centers like New York. The accumulation of diverse populations, landmarks, money, power, art, and media here means that we are a powerful cultural apparatus that influences the world. The result is that New York and its

cultural production are even more of a target for the twisted zealots as they seek to magnify their obsessions. The corporate chains of the world have created pockets of resentment, spawning radical violence. The export of our homogeneous culture is a fact. The irony is that New York is diverse and welcoming to every culture, religion, and idea that is represented in the world. Still our museums, buildings, Wall Street, have become lightning rods for hate.

The twisted villains have attacked the symbols of capitalism and culture in New York. Harming our landmarks has become sport for the crackpots trying to build their fundamentalist vision. The buildings are the tallest, the most important, or significant because of what they house – centers of finance or repositories of art treasures. What these nut-jobs don't understand is that our cultural values are inside us and not resident in a structure. The freedoms of equality, justice, and choice span our beliefs and cultures. Freedom of speech cannot be bombed. Our financial markets are the engines of our influence. Communication technology has spawned free exchange of information that pushes our ideals to the end of the earth. The Internet has supercharged the transmission of our ideas of freedom and capitalism to a receptive worldwide audience. Our status as *haves* in a world of *have nots* has become a mantra. The villains have missed the real target – our ideals. New York is an icon because of our people – people from everywhere who are driven to excel in finance, media, services, and culture.

The Internet stories have again taken a sudden turn. The headlines focus on evidence that the con-

duits contained a fiber optic backbone that helped link the island of Manhattan via trans-Atlantic crossings to Western Europe. Some connections to Europe have been temporarily disrupted and some think this may have been the real motive of the attack. The Brooklyn Bridge's fiber optic spine was one of the major regional distribution lines connecting the city and it, not the bridge itself, could have been the target. The 1996 Telecommunications Deregulation Act privatized tele-communications in the United States. Opportunistic companies quickly and optimistically built dark fiber optic networks across the globe. National and interna-tional companies, which created the resources to invest on this large scale, built these distribution arteries along highways and rail lines and inside urban infra-structures. Cities were connected to other cities and trans-Atlantic connections were built to create com-munication capacities that would instantly swallow distance and connect events. American cultural influ-ences became global. Immediacy and accessibility became the new reality and changed the world. Now these links permit the powerful and successful to create virtual desire in the far reaches of the world. If the attacks were out to sever our fiber optic links, it might prove much more devastating than blasting cultural treasures.

I wonder, is this a terrorist "Rope-a-Dope"? Have we witnessed a series of cultural attacks designed to distract us from the true intention of disconnecting the whole city? Muhammad Ali invented a boxing strategy to defeat the stronger George Foreman in Zaire ("The Rumble in the Jungle"). By absorbing Foreman's

incalculable punishment, round after round, without any offense of his own, he let Foreman wear himself out. Foreman thought Ali would eventually crumble, but Ali's plan was to attack once Foreman had winded himself. In the last round, Foreman could barely lift his heavy arms as Ali came to life and defeated the exhausted giant. Perhaps some sect has just built a twenty-first-century Trojan Horse. Those bastards! We are involved in a modern-day siege epic and we don't even know it. They must be laughing their asses off right now.

How vulnerable are we? Will one cable matter at all? I toggle on through the web. I quickly learn telecom links rely on fiber optic networks that link sites. Each distribution point is critical. The national-scale networks run along public and private right-of-ways like highways or rail beds and terminate at data carrier hotels. These hotels are usually existing industrial-era buildings in urban centers. Mass bundles of fiber optic lines that carry vast quantities of data are linked into these data hotels. The mass bundles are split into a number of smaller regional bundles that split again into local lines. The hotels are also known as peering points, network access points, or neutral access points, but are essentially described as a data bottleneck. They are the points where telecom providers and major Internet services are linked to provide data access to customers.

The industrial-era buildings were former factories or warehouses that have limited value as offices. The telecom industry recognized the potential of these inexpensive and centrally located storage spaces for use as data switching stations. Most have been rendered blast-

proof against conventional explosives, and sufficient redundancy has been built into the network.

The pop-up news on the web now reports that "experts" are providing opinions about possible tele-communication hotel attacks. Under certain circumstances, communications could be disrupted.

I remain curious about telecom hotels. Via Google, I discover that many are listed with specific addresses. It's just too easy to find their locations. Sixty Hudson and 111 Eighth Avenue in Manhattan. Structures in Newark and Brooklyn. And on and on. So much for the President's pledge to stop terrorism. Could it be possible that these critical data links to and from New York, carriers of our financial and cultural productions, are so accessible? Most are located along public streets. Anyone with malicious intent could cripple our global communications. A simultaneous cyber-terrorist attack could sever the information and business links of a major city, throwing global economies into a deep recession. Culture is also being attacked, since it can't exist without a healthy economy. This is our vulnerability. All the attacks on our buildings, last week's tear gas at the Met – are only distractions. I feel we've been made the fool again.

Another series of explosions rocks New York. It sounds like an enormous machine gun, calibrated to fire in a precise sequence. I dial Arnie to see if he got home. My apartment lights dim, then pulse. Eventually there is only the natural light from the windows. "Arnie, you home?" I am leaving a message when the phone cuts out. The Internet is gone too. I am in a state of unknowing. What is this? Am I in danger? Will there be more explosions, mass destruction? Have many people

died? I am isolated. I am afraid to go outside. I do not know what to do.

Out on the street, a man tells me the explosions were high-powered microwave bombs (beer cans) that destroy delicate electronic systems without the loss of human life. Either these people are Buddhists from Bhutan who want to attack pervasive Western culture without loss of life, or devotees of Dapper Danny Ocean in *Ocean's Eleven*. In any case, the entire telecommunications switching system to and from New York is destroyed. We are all marooned. We can only communicate through person-to-person meetings, the mail, or the radio. I ponder what it means to never again have access to the Glenn Miller Fan Club website.

Ghost Writers in the Sky

You know, it's always seemed to me that the role of the private eye and the role of the artist have a lot in common. We both try to make sense of the world. We look for clues. We read the signs. We see significance and meaning in the things that other people see as useless or irrelevant. We're interested in pattern and order and dirty little secrets, and of course we're looking for solutions, though we realize there are no easy answers, and that most "truths" are provisional.

The difference, I guess, is that artists have truckloads of money, recognition, transgressive sex, travel, and "genius" grants – okay, well, maybe not all of them. Whereas even the most successful private eyes – and by industry standards, I used to be up there with the best – we don't have much more than a hat, a gun, a police scanner, and a bunch of pornographic "compromising" photos that we shot through a telephoto lens. It's not much to show for a lifetime of sleuthing and probing the limits of human motivation.

After the disaster, you might have thought there'd be plenty of work in New York for a guy like me. Everyone

was asking the same basic question: "What the fuck's going on here?" And nobody was coming up with any answers. Instead of relying on their own half-assed, half-baked ideas and prejudices, wouldn't it have been smart if one or two people had turned to a professional? Wouldn't it have been a good idea if somebody had said, "Hey, this looks like a case for a hard-bitten private dick with the hands of a longshoreman and the soul of an aesthete?" But hell, no. They preferred to stew in their own ignorance and conspiracy theories. War, what is it good for? Not the gumshoe business, that's for sure.

The sign on my office door says, "Mark Roscoe, P.I." There, but for a small speech impediment. . . . I was dozing through a long afternoon, hoping the world wasn't going to blow up around me, and trying to keep my thoughts and hands away from the office bottle. Suddenly and simultaneously there were two noises; a distant explosion and a knock on my door. The latter was way more surprising than the former.

I shouted, "Come in," and a young woman invaded my territory. I didn't mind. She was the kind of woman who'd make a quisling out of anybody.

"Hello, Mr Roscoe, I'm an artist." All my life I'd been waiting for a woman to say that to me. "My name's Kiki Sweetstuff," she continued. "It's ironic, right?"

"Whatever you say, Sweetstuff."

She had the artist look down pat – well, at least one of the looks: tangled black hair, paint-splashed boots, a Cooper Union T-shirt, a detail of Picasso's "Minotaur With Nude" tattooed on her shoulder. She was working all the angles, pressing all the buttons.

A part of me wanted to grab her and writhe naked with her on a canvas smeared with pigment, but all I said was, "What kind of artist?"

"I make word art," she said, and I nodded like I knew what she was talking about.

"You know what I'm talking about," she said. "Ed Ruscha, Jenny Holzer, Fiona Banner. It's not rocket science. You take a word. You paint it big on a canvas and suddenly it's no longer a word. It's an image of a word. It no longer has its dictionary meaning. It's just a picture. Or is it?"

"Is that what you want me to find out for you?"

"I was being rhetorical."

"I knew that."

"Look, Mr Roscoe, there are a lot of bad things going on in this city, but you know the worst of them?"

I went through my own mental checklist: terror, looting, mob rule, the risk of sudden death, gang rape in all its many forms. Before I could choose one she said, "Someone is blowing up bookstores."

I would have had to say that on the grand scale of what was happening all over New York this seemed like a minor offense, but I didn't argue.

"You're familiar with Heinrich Heine?" she said. "He told us that whenever books are burned men also, in the end, are burned. So when they start blowing up bookstores. . . ."

I could have said that they'd already blown up a whole bunch of men, and women and children too, but I didn't. Arguing with a client is no way to get hired.

"So you want me to find out who's blowing up bookstores and why?" I said. I'd had worse cases.

"I think I know who," she said, as she handed me a creased Polaroid. It showed a bald, tubby, middle-aged man.

"This is Max Masterson," she said.

I looked at the image and said, "No, this is just a creased Polaroid," and she seemed to like that.

"Yes," she said, "a creased Polaroid of Max Masterson, another word artist, my former teacher. These explosions have got his signature all over them."

"How do you know?"

"Intuition," she said. "We artists have a lot of that."

I looked at her skeptically, and she softened. "Mr Roscoe, I just want you to make him stop. I don't care how you do it. I assume you have your methods. Maybe you could reason with him. If that doesn't work, scare him a little. Straighten him out. Save him from himself."

At that moment her cell phone rang. She listened to a voice on the other end and grunted a reply.

"They just took out Barnes and Noble in Union Square," she said. "That was the explosion we heard as I came in."

I could believe it. I opened my window, sniffed the air, a smell of charred paper, glue, ink – and then the debris started to float in – little strips and shards of paper that had been shredded by the explosion. I plucked one out of the air.

"In my end is my beginning," I read.

"It sounds like art," she said, and I tried to convince myself that I understood what she was talking about.

"Why are you so concerned about this?" I asked.

"We artists don't need a reason. But I do happen to like bookstores. It'd be hell if the Strand were to go."

I wasn't too proud to accept a fool's errand. And I wasn't too proud to salivate at the prospect of Kiki Sweetstuff's money.

Max Masterson lived in a loft in SoHo. Yes, he was evidently one of the ones I was talking about: an artist with money, fellowships, residencies, and so on. Okay, so maybe he'd been there in SoHo since the early days, but if he'd ever starved in a garret it had been a long time ago.

I walked up and down outside his building, looked up at the top floor. I could see an easel positioned in front of one of the windows, but there were no signs of life. I crossed the street and sat in a smoothie bar, from where I could keep an eye on things.

After a couple of hours I was approached by a bald, tubby, middle-aged man carrying a couple of full shopping bags from the Strand, and he said, "Are you stalking me?"

It was Masterson, though he looked older and heavier than in the photograph Kiki had shown me.

"Moi?" I said.

"I know you're up to something," he said. "I've been looking out my window. I've seen you staring up. We artists notice shit like that."

"Not stalking," I said crisply. "Though I am a big fan of your work."

"Oh yeah? And which work do you like best?"

He said it like it was some big, serious test question, but I just replied, "The transitional stuff," and he seemed to like that.

"Okay," he said. "Why don't you come up to the studio? Less chance of snipers up there."

This was going well, maybe too well, but I figured artists are sad, lonely people, they'll talk to anyone. We went up in a freight elevator that was big enough to carry a horse.

Masterson's studio was a big, empty, ugly room. There wasn't even that much art in evidence, just a big canvas with the outline of two words painted on it, the words "Jerking Off." It struck me as kind of self-indulgent.

"Gee, Mr Masterson," I said, "where do you artists get your ideas?"

He looked at me like he wasn't sure whether I was a pathetic simpleton or a sarcastic son of a bitch.

"No, really," I said. "How do you know which words to paint?"

"Now, that's not such a bad question," he said. "Fact is, there are so many damned words to choose from. Which one, out of the hundreds of thousands of them, do you pick to make your word art?"

I figured it was another of those rhetorical questions so I kept my peace.

"Sometimes it seems like choice is the whole problem," he said. "Maybe the artists shouldn't choose at all. Maybe they should let chance decide for them. I've tried a lot of strategies: opening a dictionary at random, putting words in a hat, turning on the radio and using the first word I hear. But, you know, it never seems quite as random as I want it to be."

"Must be tough," I said.

"It's hell. But lately I've come across something," he said. "Since the disaster there's all this airborne matter, paper fragments, some with words on them. I've found it pretty inspiring."

I wondered why he was telling me this. Was it a sort of confession? A James Bond moment when the villain suddenly decides he needs to explain just how clever he is?

I looked at a notice board over on one side of the studio where he'd pinned up tiny fragments of paper, each with a word or two on them: his raw material, his sources of inspiration. I couldn't help noticing there were also a couple of images of mightily breasted women.

"Do you know Kiki Sweetstuff?" I asked.

"Sure," he said, though his face suggested that maybe he wished he didn't. "She's one smart artist. Derivative, though."

"She thinks you're insane," I said.

Masterson shrugged, "I guess it's not much of an insult to accuse an artist of insanity. Some of them pride themselves on it."

"She thinks you're blowing up bookstores," I added.

"Well, I'm not," he said.

"But you would say that, wouldn't you?"

"Look, shamus," he said, "I know where Sweetstuff's coming from. She was at a seminar I gave a couple years back. Art and destruction. I posed a very simple question: was it justifiable to destroy property, books, buildings, maybe even people, for the sake of art. And you know, in the end I concluded that it was. But hell, I was only being a provocateur. I was only being theoretical. A smarter student than Kiki Sweetstuff would have understood that."

I looked at Masterson, at his big open face, at his big spatulate hands, and I knew exactly what I had to do.

Next day I called Kiki and told her there'd be no more trouble from Max Masterson.

"Did you reason with him?" she asked.

"Only up to a point."

"What point?"

"Until the point where I broke his hands."

"Both of them?"

"Sure. He could've been ambidextrous for all I knew."

"Wow."

"Yeah, he won't be working on 'Jerking Off' for a while."

She told me the cheque would be in the mail. I suggested we get together, that maybe I could come up and see her etchings. She said she didn't do etchings. I said how about mezzotints? She laughed at me. It hurt, but you know, I kind of enjoyed it.

For the next couple of weeks, the city was free of exploding bookstores. I'm not saying there weren't plenty of other despicable acts going on, but at least the bookstores stayed intact. That had to be a good thing, and since I'd played a part in it, I should have been happy to take some credit. So why didn't I feel happy at all? Even the arrival of Kiki Sweetstuff's cheque didn't soothe me.

Kiki continued to be much on my mind. In fact, for these same two explosion-free weeks, I'd found myself following her. I couldn't entirely have told you why. Call it a hunch. Call it creepy and stalker-like if you prefer. But stalkers like their quarry to be aware of them, and Kiki had no idea I was following her. Hey, I'm a professional. I'm good at what I do.

I stuck close behind her as she visited a number of bookstores, including the Strand. I found that kind of

suspicious. She also visited a bunch of newsstands, magazine stores, a couple of old-fashioned dealers in "esoterica" (that's "filth" to you and me), and even art galleries where they kept a good stock of catalogs. I guess any one of them might have been a source of artists' supplies, if you were in the business of blowing them up in the name of word art.

It was only when I followed her to the New York Pubic Library three days in a row that everything fell into place. I'd been an idiot. I'd been thinking too small. Oh sure, a bookstore offered a certain amount of material, but compared to the NYPL it was nothing. And we weren't just talking about books here, we were now talking about maps, legal documents, sheet music, ephemera, all manner of personal, photographic, and sound archives. And that also meant we were no longer talking about word art; we were talking about collage, assemblage, mixed media. Kiki Sweetstuff's art was developing.

Yes, that's right – Kiki Sweetstuff. She was the real artist behind all this. She'd got me to terminate Max Masterson's career, not because she cared about saving books or bookstores, and certainly not because she cared about saving the old guy from himself. She'd done it because she wanted a clear field for her own career. She'd taken Masterson's idea and was running with it, fast, and it looked like I was the only one who was likely to stop her. Who else was going to do it? A cop? In this city? In these troubled times? Get real.

I confronted Kiki Sweetstuff in the gift shop of the New York Public Library. She was buying a pair of salt and pepper shakers in the shape of the Empire State and Chrysler Buildings. Cute, huh?

"It's over, Sweetstuff," I said.

"What's over?"

"The art game. Your art game, anyway."

She played the innocent, of course, pretended she didn't know what I was talking about. So I enlightened her, told her what I knew and what I'd worked out, the whole story. She didn't deny it, just listened, shook her head, and at last said, "You think you're pretty smart, don't you, Mr Roscoe?"

I took that as confirmation that I was right.

Then she got angry.

"You're an idiot, Roscoe," she said. "You're a philistine. You know nothing about art."

I wasn't going to stand there and listen to that. I guess there was a time when a man couldn't handcuff and gag a suspect and then march her openly through the streets of Manhattan, but those days were long gone, fortunately. I wouldn't say she came quietly, but with the gag in place she wasn't in a position to do much talking.

I took her to my office and sat her down in my revolving chair. A part of me wanted to strip her naked and paint a Jackson Pollock all over her with my bodily fluids, but instead I reached for the office bottle, and I reckoned we were going to have a little private seminar on art and morality.

That was when the New York Public Library blew up.

Of course I didn't immediately know that's what it was. From where we were it was just an unholy, devastating explosion, and not nearly as distant as I'd have liked it to be. I had to get on the police scanner for confirmation. It seemed I'd failed completely.

"How the hell did you do that, Kiki?" I asked. "Remote controls? Timers? Robots?"

She mumbled something passionate and incoherent through the gag, so I removed it.

"I didn't do anything," she said fiercely. "You got it wrong. All wrong."

"But you said I was smart."

"Yes, smart but wrong. Your line of reasoning was very clever. Creative even. It just happened to be totally misguided. I told you Masterson was the one blowing up the bookstores, and it was true. But artists like change. He'd had his bookstore period, now he's moved on.

"I started following him. He kept going to the New York Public Library. That's the only reason I kept going there. I put two and two together. I could guess what he had in mind. And I hoped that maybe I could succeed in stopping him where you'd failed. But then again, maybe I was a fool to think either of us could ever stop him."

"But I broke his hands," I said.

"I guess he has assistants. A lot of artists do these days, you know."

I took the cuffs off Kiki. She rubbed her wrists for a second, looked out into the street, then began clearing off the top of my desk. Simultaneously she told me to open the window. I did as she asked, though at first I didn't know why I was doing it. But then, before long, debris started to float in through the open window and some of it landed on the desk's surface. Sure, a lot of it was just dust and rubble, but there was a lot of valuable matter there too: shards and slices of material from the various collections at the New York Public Library, everything I had already imagined, all the books and archives, all the

words and images, some noble, some banal, some down-right smutty, all reduced to a terrible airborne confetti.

I looked at these fragments on the desk, at this evidence of ruin, and I don't know why, but I couldn't stop myself. I began rearranging them, creating patterns, order, new meanings.

Kiki Sweetstuff looked at me and seemed to understand. She placed a sympathetic hand on my shoulder and said, "Why, Mr Roscoe, it seems you're an artist after all."

That was another thing I'd been waiting a long time to hear a woman say. I grabbed her the way Otto Mühl used to grab geese. She responded by yanking off her T-shirt to reveal two wanton but pert breasts, the nipples pierced, a tiny replica of Serrano's "Piss Christ" dangling from each.

"I think we should collaborate, don't you?" I said, but it didn't need saying. We had already begun to create our personal master-piece of lust.

Kiss of the Worm

With desperate efforts to make time useful. And compact. Frantic sorting through bits of paper coagulating in the bottom of my bag . . . filing receipts . . . refreshing my lip gloss . . . compiling all pens into a single pocket. Moments in transit become the space of personal organization: bill-paying, beauty maintenance, inventory assessment. Oddly too, a spectator sport. Performing domestic or administrative tasks for an audience of strangers breeds efficiency and focus. I take advantage of this often. Today, I created a deadline for myself at 72nd Street. All in the great hope of being better prepared for what awaited me at point B of my travel path.

Inevitably in this scenario, the completion of all tasks at hand has the abrupt finish of a standardized exam. Pencils down. The train screeched to a halt at Chambers Street. Doors opened.

As I emerged from the subway, a great explosion transformed the sky into a blinking bubble of luminescent tendrils. Was I too late? A single clap of deadening sound followed by an effervescent puff of squeaks and cracks: I was late! The surrounding tall buildings seemed to sway like fingers on a hand waving hello. Chains of

people linked like paper dolls streamed in all directions criss-crossing the empty streets. The complexity of motions at eye level seemed lifted, almost airborne, by the banners and flags flickering in vivid streaks overhead. Patriotism had taken on the sentiment of color war. After a quick and failed survey of best possible routes, I joined the masses funneling into the Wintergarden to capture the best view of the Fourth of July fireworks.

During the day, the Wintergarden has the tacky appearance of a vacation souvenir, a glass jewelry box won in a Florida bingo tournament. I imagine flowers etched in the center of each beveled fragment glinting in the sun. Now, in the darkness with lights out, the heroic structure seemed to disappear into the night.

I scanned the crowd seeking a way to advance my position in line. At a complete standstill, with toes pulsing inside my shoes, unfamiliar faces, police barricades, mounted officers, and velvet rope whipped into a motion blur. My tongue pressed against the roof of my mouth, I wedged my thumbnail between my two front teeth.

Mesmerized by the intensity of activity, my head drifted side to side; the scene felt so familiar. I thought to marry the moment with a sci-fi film. Instead, I shook my head hoping to shoo the distraction and imagined the thoughts like flies fluttering around my fragrant hair. Even dire circumstances leave space for daydreams. Again, remembering the purpose of my visit, both terrifying and sweetly awkward, my eyes opened wide. With a quick nod, I recalled an alternate entrance to the Wintergarden through the Embassy Suites Hotel. I headed north on foot.

Something like an exquisite corpse exercise, two faces split across my nose: intense eyes sharply focused with a visible giggle crossing my lips. An unimaginable threat to world economy, the mass destruction of New York City infrastructure, the foreseeable future hinged on my "blind" date at Johnny's Fish Grill!

Earlier today, I had received an unexpected phone call from my most detested professional archrival, Stefan Masur. A man I have never met. I was hired to replace him at DBLO and we have since remained in a state of vicious rivalry.

"It seems we have something more in common," he spoke blankly. His voice was different than I had expected, soft, breathless with metered articulation.

"Oh?" With my best attempt to seem alert, I could not resist a chilly response. During the quiet pause, my alarm rang to wake me from my nap ". . . Oh, freak that. . . . Come here, baby . . . grab me from the back. . . ."

The dial was set to National Public Radio for the morning news but at this late hour is at the mercy of local programming. I completed the verse – "Baby, you the mack . . ." – and then reached to silence it, embarrassed by having been caught asleep but amused by the musical accompaniment. I hated the thought of anyone knowing that I slept. It seemed like the ultimate weakness.

Stefan pressed on: "A logic bomb! We are under siege."

I had probably overdone it the night before. Lately, after work, my team had skipped the white collar frat farm for a Chinatown karaoke dive, a dirty, woody bar run by three generations of Vietnamese hookers. Rounds and rounds of cheap tequila had resulted in some fairly

brutal renditions of eighties rock songs. My raspy voice at five-thirty this late afternoon served as evidence of the damage done.

"Do you know what a logic bomb is?"

I considered lying but decided against it. "I do not."

"A logic bomb seeks and occupies security holes in vulnerable servers and invokes an unauthorized act at the moment when a certain event occurs in the system."

I remained quiet, hoping that he would offer more information.

"Do you remember the Code Red Worm?"

"Well, yes of course!" I shouted, pleased to be able to respond in the affirmative.

I did suppose that "bombs," as "worms," always had evil intentions. Hard to forget the infamous Code Red Worm that spread itself by creating a sequence of random IP addresses to infect unsuspecting web servers. At precisely eight o'clock in the evening on July 19, 2002, each infected terminal sent multiple emails to a single address: *whitehouse.gov.* Having infiltrated hundreds and thousands of machines, the worm orchestrated a mass bombardment of the domain. Initiating an overflow of simultaneous connections to a single port ultimately resulted in a shut-down of service and substantial damage to the server.

"It works like toilets in jails," I added.

I had read a story once about a mid-western county jail that had to deal with the massive problem of inmates flushing sheets and clothing down toilets. Once these materials were in the drain line, the original toilet would flood, as well as any other toilet on that same drain line.

Today, correctional facilities use programmed plumbing control systems to limit the number of toilet flushes throughout the building within a specified time frame, thereby preventing inmates from intentionally flooding prisons through "simultaneous flushing" and other acts of vandalism. An analog example of our impending virtual crisis! I did not really elaborate on the connection.

"Anyway, Amanda, listen . . . there's no time to lose. Both servers have already been intruded with subsequent threats by telephone. The Fourth of July fireworks begin on the Hudson River at sundown, nine o'clock or so. At this very same moment a logic bomb will initiate an electronic flooding of the New Jersey information facilities which house both of our servers."

He continued: "By getting together and comparing notes, we could determine the nature of the security breach, the means of access, and possibly the identity and purpose of the assailing entity. We may also be able to determine if company employees were directly involved with password code breaks either intentionally, through blackmail, or by identity theft. This information could help us to shut down the criminal operation before disaster strikes.

"I mean, think, how did all of those companies in the towers get into their systems in the aftermath of 9/11?"

Survivors got onto the desktops of the deceased, locating the usernames and passwords required to reboot systems. They knew things about one another personally, where they grew up, their kids' names, wives' names . . . that enabled them to break into those IDs and into the system to be able to get the technology up and running. It was personal knowledge that made the difference.

I added aloud: "Close contact and relationships of trust. Without this knowledge, there is no technology and no information."

"As I see it, we need to confide in one another the workings of the corporate system technology that we develop and operate . . . all passwords, codes. I suppose that we need to get to know one another. . . . This will be our only chance to interfere with the course already set."

And so we arranged to meet for cocktails . . . to find privacy among the masses in a location where we could never be singled out.

As I hurried to meet Stefan, my steps merged into a sort of galloping gait. My laptop case kept time on my right hip. Moving in the opposite direction of traffic, I was able to squeeze through even the densest crowd without skipping a step! Approaching the Embassy Suites Hotel, I adopted a rhythm of motions and breaths reminiscent of high school lacrosse drills . . . alternately turning sideways and forward and sideways again. I successfully bypassed the doorman in white gloves and the slow and sparkling revolving door, which always reminds me of a dessert display case at an upstate diner. As I passed through the membrane which separates every hotel from the outside world, I reassumed my typical posture, composure, and slow, sure step.

I seemed to have made up for lost time until a woman with extreme hair made her way toward me in the lobby. She had a funny shape and an outstretched arm, but it was the intensity of her coral-colored lips that obliterated all other defining features.

"Amanda! Amanda!"

I cringed. Her aggressive tone and the nasal A were a clue, and her enunciation of my name, unmistakable.

"Amanda, I'm so glad to run into you. You studied architecture at Cornell, didn't you?"

I stared at her in disbelief. I had just declined the invitation to my fifteen-year reunion.

"Did you see that architect on 'Charlie Rose'?" She ground her back teeth, which caused the glands in her neck to flare. "Well," she swallowed, "what he did to New York is unforgivable! Hit us while we're down!" I could hardly stage a reaction; as a result, her histrionics became more aggressive and colorful.

"He has an accent; I think he must be German." My curiosity got the better of me. I determined that she must be referring to the overexposed architect Rem Koolhaas. "Just because he lost the Whitney project, he's totally sour grapes. He said New York is done! Finished!"

I recalled the last time I saw Lynn Gold, her cheeks were pressed between two black vinyl support pads as she received a seated massage.

"Who signed up for reflexology at 11:20?" A kind of triage, a makeshift spa had been set up to palliate the hordes who had shown up for the rained-out ladies' golf tournament. Trying to find my mother, I made my way down the long corridor to the clubhouse. It was double-loaded with outstretched calves glistening, a kind of female counterpart to an airport shoeshine. The legs seemed still and taut in a perfect state. Heads and arms seemed entirely disconnected in a haze of flapping and chatter. It was loud. As I made my way around to the back of the serpentine queue forming,

the sharp smell of acetone was quickly muted by a chaser of almond oil.

"If he loved New York. . . ? How could he say these things when we're in such a fragile state? I mean, we're hanging on by a thread!"

I let her keep talking. She spoke slowly, mechanically, as if a ventriloquist was projecting the sounds emanating from between her terse lips.

"Do you know how bad things are? The fear! If one more thing happens, just one more scare, my Karen is going to take her kids and leave the city!"

My silence was like a call to arms. She continued: "When I need a new pair of stockings, I'm terrified. You don't think I put myself at risk, do you? No! I send my housekeeper out to Bloomingdales . . . because I'm telling you that that is where the next one is going to hit!"

I thought to mention that Rem Koolhaas was actually Dutch . . . but I really had no time to extend the chance encounter. I excused myself and hurried along. I hoped that an air of privilege would identify me as a hotel guest and that confidence would admit me without a room key to the underground causeway connecting the Embassy Suites Hotel to the Wintergarden Food Court.

The World Financial Center transforms into a real-time "Working Girl" fantasy every summer Thursday . . . and this "Fourth" was far from an exception. The scene typically stars an inflammatory mix of hopeful administrative assistants seeking early retirement into house-wifery and young financiers seeking a reason to wear the same suit to work again on Friday. The horseshoe of bars and restaurants that normally delineate a glossy interior food court spills out onto the broad promenade that

separates the Hudson River from the World Financial Center point towers. The concentric rings of activity radiating from an empty center form a traditional style of outdoor arena. Each ring is defined by swags of white plastic nautical chain.

The marina mirrors the arc of the granite-clad buildings to form the outermost ring. The next ring toward the center allocates a region for socializing while standing, a kind of casual noncommittal slip of space where one can just as easily strike up a conversation as terminate one. The third ring houses outdoor tables, "private keg service," and most of the noise. Gangs of co-workers assemble, having sent representatives out early to hold tables.

At the center of such commotion, in the enormous void, you might expect a Greco-Roman wrestling match to be taking place. Instead, the empty space exists as a sprawling catwalk where each trip to the lobby restroom becomes an opportunity for exposure. The "models" adopt the self-conscious swagger of a runway show. Noticing my own gait, I landed my footsteps in a perfect line. I had spotted Johnny's Fish Grill across the expanse of concrete.

In a dramatic gesture, I pushed my way through the saloon doors, leaving them swinging, as I entered the long narrow space. I recognized Stefan immediately; he did look quite like his glossy corporate headshot. He sat in a round, tufted vinyl booth facing the entrance with a phone tucked between his chin and shoulder, his left hand extended, veins visible from a distance, and a blue light cast on his face. I approached the table and stood beside him for a few moments until he noticed. Startled, he repressed the impulse to jump to his feet and decided

instead to slide counter-clockwise along the shiny black seat, creating a space for me to sit.

"Hi."

"Hey, glad you made it. No major updates yet. Let me fill you in on our course right now. I am running statistical analysis to try to build a better picture of who the attacker is and the magnitude of the threat. I thought we could work through similar and simultaneous measures, comparing findings along the way to determine what we may be up against."

"Have you made any progress? Have you determined the style of password theft? An infinite number of random, digitally generated attempts? Dictionary searches? An algorithm? Or is this attack based on knowledge, perhaps requiring involvement from someone on the inside?"

I ordered a Johnny Walker Red at the first opportunity and opened my laptop.

Stefan planned to "conference in" three other Chief Communications Executives from major institutions. As a result of a mandate issued by the National Infrastructure Protection Center in 2003, all five of our companies had dispersed operations across the metropolitan area to diffuse the possibility of a geographically targeted terrorist attack. Our high-tech operatives, primary server facilities, and technology officers were now located offshore in New Jersey, Brooklyn, and Long Island City, forming a ring around Manhattan.

Having identified a security breach and shortly thereafter receiving a threat by phone, Stefan orchestrated a highly unlikely meeting as a means to consolidate data. A pub crawl. The three other guys were at a

nearby Irish tavern inside the World Financial Center. The plan was to convene and communicate in various and changing partnerships until we could recognize the patterns of attack that affected us all. The strategy takes advantage of the mass confusion and distraction of the public holiday: staging meetings in multiple locations, offering us alternately privacy and contact, as needed.

For each of the five of us, our offshore operatives were connected to the series of real-time meetings by earpiece, acting on the information shared . . . deciphering ID codes as a means to enter and potentially decontaminate each server.

Slowing the pace of our conversation, Stefan turned to face me, his clear blue eyes alight. The line was rehearsed, as was his gentle sincerity. "So, is your system set up to offer a single entity unlimited access?"

For all I knew, Stefan was the mastermind behind the attack. As is typical, his earnestness made me suspicious. I struggled with this, playing out a variety of scenarios in my mind before answering the question. I was tantalized by the risk of trusting him. Of course, in this emergency, there really was no choice. Our efforts would have a short life span, either in success or failure. And as dire and dangerous as the situation was, it felt sexy. After a few more whiskeys, the threats seemed a thrill.

I described to Stefan in detail the workings of our server. I enjoyed feeling so vulnerable.

"We have established a network approach to access, offering only partial access to any single administrator."

Just like Colonel Sanders' secret "Original Recipe." No single KFC associate has knowledge of the complete list of ingredients. The fragments, when assembled, form

the whole. One company blends a formulation that represents only part of the recipe. Another spice company blends the remainder. A computer processing system is used to safeguard and standardize the blending of the products.

It was quite a kickoff. Corporate America protects its infrastructural secrets vigilantly. I have rarely had a conversation that personal with my own staff. Maybe I wasn't so warmed up.

Stefan switched gears and patched together our five-way conference call.

"Hi."

"Hi."

"Hi there."

"Hi."

"Hi all."

After the greetings, there was near-silence on the line. Only breathing and keyboard chatter. But it did feel good to have company.

"Hey, did you guys come up with anything yet?" I pressed the earpiece further into my ear.

"We're working on it. It seems that the 'Freedom Worm' spreads in files attached to email messages with faked sender addresses and vague subjects. When users open the virus file, the worm is launched and alters the configuration of Windows so that the worm program runs each time Windows starts. It also scans the hard drive of infected computers, harvesting email addresses from a variety of files."

Another voice added: "The worm then uses those email addresses to target other users, sending out a flood of messages. Once an enormous network of infiltrated

systems is established, each terminal, maybe millions of them, is armed and ready to launch an email, collectively bombarding a single domain. We are not sure what the implications are yet."

"Stefan, how about your guys?"

"No, nothing concrete yet. How about the others? Tom, Scott, Brad?"

As they reported their discoveries, I studied Stefan's brow, his chin, his shoulders. I bit my lower lip.

The sky had grown quite dark and the crowd's anticipation hovered over the marina. The barges had taken their places in the Hudson. Suddenly, a second round of fireworks launched into the sky. Red, blue, and white. The white bursts left a tidy trail of wormlike streaks.

Stefan's brow narrowed; he was listening intently. "Okay. Right. Excellent work." His stare shifted as he began to relay the latest communication.

"The clock is ticking. It seems that the complete bombardment of all five servers will occur in exactly twenty minutes. My guys think they can minimize damage significantly by establishing a series of partitions. And we have already backed up the entire system."

The rest of us repeated this information into our mouthpieces tailoring the strategy to our own systems, proposing a course of action accordingly.

Stefan lifted his beer to his mouth. A cocktail napkin stuck to the bottom of his glass and then fluttered to the floor. When he reached under the table to retrieve it, I intercepted his hand. He squeezed mine back and guided our hands together to rest on the seat between us. With a tug, he pulled me to face the window and we sat for a few minutes gazing up at the

brilliant globes of color forming in the sky. The murmurs of Scott, Tom, and Brad were still audible by speakerphone over the loud bangs echoing across the granite courtyard.

Stefan turned to face me and slowly drew his face toward mine. "Shall we begin?"

I threw out the first question: "What is your mother's maiden name?"

"Cooper. What is your date of birth?"

"November 11, 1964."

We continued to exchange these banal questions in the hope that the newly formed ties between our companies could be broken. If each of our identities had infiltrated all five companies, then by sharing password data we intended to shut down the logic bomb before the slag code was activated. But time was running very short. We were racing against the clock.

"What was the name of the street you grew up on?" Stefan lightly skimmed the flat of his hand across my cheek. His fingers landed on my shoulder. Just as he kissed me, Brad called out on the speakerphone: "Are you guys ready to mix it up?" We held back our laughter. I hung my head low and closed my eyes to avoid eye contact with Stefan.

"Perhaps that's no longer necessary? I think our time might be better spent staying put."

Stefan reached for me again and kissed me, this time with even greater confidence. I swung my left foot back and pressed it hard against the floor to stabilize my posture. While he faced the bar entrance, I could view the fireworks out the window. The ambient buzz of the cheering crowds suddenly burst into a roar. The finale!

We jumped from our seats and ran outside to watch. Launched from a bed of flames, a steady stream of fireworks ignited the sky. Each blossom was accompanied by a gunshot.

I felt a vibration inside my ear, and ducked down and cupped the earpiece.

"Amanda, Amanda . . . it's too late. The flood will occur in thirty seconds. We have everything backed up, of course, but we will lose our server. Amanda?"

He continued in quick sputters: "We have just discovered that the email bombardment will coincide with a shutdown of power. Two events will be simultaneously triggered into action. One slag code will overload the server with a mass bombardment of email. The other will abruptly shut the server down. This will result in an enormous power surge, a spike, which will at best, black out the entire metropolitan area. At worst, the surge could explode the buildings, the server itself acting as a bomb."

"Oh, god."

"Amanda? I think something . . . the lights. . . ."

At that moment, the connection failed. The sea of lights reflected in the Hudson went black. I lifted my gaze; New Jersey had gone completely black. The crowds cheered as the fireworks beamed crisp and bright in the pure black sky. It seemed to be part of the show. The fireworks hung alight and aloft for an impossible minute, stuck in the smoky haze. After a moment of silence, a huge bang then a fiery explosion engulfed the last sparkles of the finale.

"New Jersey City!"

A delay and then, a slightly muffled bang: a torch ignited the horizon encircling us, a crown of flames.

"Long Island City!"

The bangs grew more muffled, but continued as Stefan and I held each other close.

Old Bridge, Old Boy

Alex was asleep. He was dreaming he was an English soldier about to go over the top at the battle of Ypres. He was standing in a crowded trench, up to his knees in mud. An officer with a pistol in one hand and a cigarette in the other was trying to speak to them. It was difficult to hear because it was noisy with explosions and gunfire.

"Now listen up, lads. When I blow my whistle you are going to climb up these ladders and attack the Boche right in front of this position. When we are over the top I don't want any unnecessary running about. I want a good steady walk toward the German line. We have to show them contempt."

Walk! thought Alex. He must be fucking crazy. Everyone will be shot to pieces.

"*Fix bayonets!*" came the shout down the line. Everyone fixed their bayonets. "*Stand by your ladders.*" Alex stood by the ladder that was going to take him to certain death. He was second in line. The officer with the pistol and cigarette was standing halfway up a ladder next to Alex, looking at a watch. All eyes were on that watch. The shell fire from the German side was now a continuous deafening roar.

"*Ready!*" The soldier in front of Alex moved a couple of steps up the ladder. Alex put his foot on a rung right behind him. "*Steady!*" There was a pause that seemed to last a lifetime and then *pheeep!* went the whistle and Alex was climbing up the ladder as fast as he could after the big man ahead of him. As he reached the top of the ladder he had one moment to look up and see a large explosion in front of the soldier ahead which blew the poor man straight back on top of Alex.

"Ohhhh!" said Alex. The large woman who had fallen onto Alex stood up.

"I'm so sorry, I couldn't help it." For a moment, he was confused and wondered where he was. Then he remembered: he was lying on a couch at a dinner party in Chelsea, New York City. He had gone there with his girlfriend and they had been enjoying their evening together. He drank a little more than he should have, and as the alcohol did its work, a couple of people began to irritate him so he retreated to a quiet corner of the living room to sit on a couch for a while and calm down. The couch was very comfortable and it was not long before he fell asleep.

Something other than a big girl and a bad dream had woken him up, however. "What the fuck was that?" he said to no one in particular.

"Explosion!" replied a voice. "There's been a huge explosion at the end of the block."

Party guests were hanging out the windows looking down the street at where the bomb had gone off. Alex walked over to the windows to have a look. There was lots of smoke and broken glass and all the car alarms in the street were going off. The dinner party guests were chattering excitably.

"Jesus, I hope nobody got hurt."

"Well, it is late and pretty quiet, round here. Looks like they blew up the gallery."

"I hate those people who run that gallery. I hope it puts them out of business."

"Maybe they blew it up themselves. You know, claim on the insurance and get famous at the same time."

"Who said it was terrorism? Maybe it was an artistic gesture."

"Someone might be hurt down there. Let's go and help."

"No, it might not be safe. Anyway here come the 911 people."

The dinner party watched as the night below them filled with the sound of sirens, flashing red and blue lights, and a helicopter. When the news teams arrived, the windows were closed and people began to move back into the room to wait to see it on the television.

Alex poured himself a drink and turned his attention to one of the guests who was sitting at the head of the dinner table, talking in a low and sincere voice to several of the dinner party about his new show. He was called Meez van Blootz and he was a very successful installation artist. Alex stood close for a while, but found listening to Meez talk about art and himself not very interesting.

Alex moved on into the kitchen to find his girlfriend, Bamber. She was leaning against a table, in conversation with a skinny woman dressed in black. Bamber saw Alex and gestured for him to join them. She hooked her arm around him, pulled him close, and introduced him to the thin woman.

"Alex, Myra is going to curate Meez's show."

"Hello, Myra."

They listened politely to Myra talk about Meez's forthcoming spectacular. They were joined by a very tall red-headed man sporting a goatee whose name Alex did not catch. It sounded Italian but he looked English or Irish.

"What do you think of Meez's concept for his new show?" Alex asked him.

"Interesting, very interesting," Mr Red replied, without taking his eyes off Bamber. Alex disliked him instantly. Bamber and Alex made their excuses and moved on. They wandered around the party one last time before saying their goodbyes and leaving.

Outside, it began to rain and the street was covered with broken glass and bits and pieces that had come from the explosion. They picked their way through the debris and walked a couple of blocks to get away from the emergency services. They decided to walk home. After the excitement of the evening it was nice to walk arm in arm together, under an umbrella. They talked about the party.

Alex told her about his vivid dream and his disapproval of Meez and all people like Meez. Bamber listened with a sympathetic ear and then made an effort to change his mood by being light and funny. She was very good at cheering him up. He liked that she made the effort for him. Why she liked him was always a bit of a mystery to Alex. He felt she could do better.

"I have to go to London in a couple of days to sort out my place for the new tenants. They move in next week. Do you fancy a quick trip to London?" Alex asked.

"No thanks, I'm busy next week," she said, "I don't like London very much and anyway, you need me here to look after your cat."

Alex walked Bamber to her door and kissed her good night. She wanted to stay at her place and he had to go home to feed his cat.

He continued his walk home. Bamber lived in a nice place on Grove Street and he lived not far away on Washington Street. The night was still alive with sirens but there were few people about. It was just after two in the morning. As he took out his keys to his house, something caught his eye in the narrow, dark alley next to his building. At first he thought it was a cat that had walked toward him, so silent was its step. But when it stopped just feet away from him, he thought it was a small dog. He looked again and realized it was a fox. A feral fox. A wild creature that did not look to man for comfort or friendship. He had no idea what it was doing in New York City. It had probably been in his alley looking through the garbage for food. They stared at each other for a long time, both motionless.

The fox's glare was dark and cold. And then it was gone, as if it never was there. Alex found the key to his front door and let himself in.

At the departure terminal, the airport security line was long and the people in charge were going about their job with humorless efficiency. Alex remembered a time, not so long ago, when airport security spent their time talking and joking and generally ignoring passengers and their luggage. Any complaints then about their efficiency were greeted with dumb looks and shrugged shoulders.

Standing just in front of Alex was the tall red-headed man he had met at the party, the man whose name he did not catch. The same man who could not take his eyes off Bamber. He looked around and their eyes met.

"Hello," said Alex. "We met at a party in Chelsea last week."

"Ah yes, that's right. You're the writer who was with the attractive girl in the kitchen."

"No, I'm the film editor who was with my attractive girlfriend in the kitchen."

Mr No Name smiled and they talked about the purpose of their trips.

Alex realized that he was neither Irish nor Italian. He was English, very English, and he was going to "an old boys" reunion at his old school in the north of England.

"Which school did you go to?" asked Alex.

"Oh, you won't have heard of it. It's called St Peter's, up in York. It really is a minor boarding school. It just scrapes into the top fifty at number forty-nine."

Alex had heard of it. He knew it very well indeed because he had also gone to school there. But he did not mention this to Mr No Name. Alex still did not trust him, though after mentioning the name of the old school he started looking a little more familiar. Alex was too embarrassed to ask him what his name was again. He had tried looking at luggage labels, but to no avail.

They exchanged a few more pleasantries and after the X-ray machines, they went their separate ways.

The plane was crowded with English people. He had a window seat and once he was settled he began to look around the plane. A passenger did not turn up for the flight and so Alex's plane had to wait while the no-show's

bags were removed. Some time after the plane had taken off, a member of the flight crew with stripes on his shirt walked up and down the aisles as if he were looking for someone. None of this made Alex comfortable, so he put an eye mask on, and switched to the classical music station on his headphone set and tried to sleep. He had a dream that he was arrested for setting off explosions and that the tall red-headed man had his arm around Bamber as they watched Alex being led away to imprisonment. They were both laughing at him.

The flight attendant woke him with a shake and shouted in his ear, "Breakfast, sir!" He sat up, removed his sleeping mask, and looked out the window. He could see land and sea below, which he recognized almost immediately. They were flying over Dingle Bay in southern Ireland. It was early morning and he could clearly see North Atlantic rollers running up the beaches and rocks of the Kerry peninsula. It looked like it was going to be a beautiful day down there. He felt a bump and a change in the sound of the engines. The plane dipped a little and began to make its long descent toward the United Kingdom.

The London taxi driver's accent and manner was incomprehensible to Alex, and the short drive from Paddington Station to his old home seemed to go on forever, and cost too much. He had not seen the square where his flat was for nearly three years and it looked different. There was rubbish strewn all over the square and an abandoned car outside the church in the center of the square. All the windows of the car had been broken and at some point it had been set on fire. Alex found his keys and let himself in.

The flat was in excellent condition. The old tenants had looked after his place very well. There were a couple of small appliances that needed to be changed but that was about it. Alex lay on his couch and fell asleep.

When he awoke it was getting dark outside. He had a quick wash and went out to the local shop to buy some milk and biscuits to have with his tea. Walking back from the shop a different way, he came across a group of boys breaking into a car. There were six of them and they all wore similar clothes: sweatpants and hooded tops pulled over baseball caps. They looked sinister in spite of their age. The oldest could have been no more than four-teen.

"Hey, stop that!" said Alex. He immediately regretted opening his mouth. The boys turned quickly toward him and two of them moved into his path. They looked at him with dark, expressionless eyes. Feral youth.

Like the fox, they were quite still. Without another word, Alex pushed past the two boys blocking his way and increased his step. Something hit him on the back of his head and a bottle flew past his ear. He started to run. Another bottle followed him and smashed on the road. Jeering laughter followed him down the street.

When he got back to the flat, he called Bamber. "I hate this place," he said.

"I know you do, darling," she said. "Come home."

The next day, Alex was very busy. He called his solicitor and instructed him to sell the flat.

He called the storage company and told them to ship the rest of his possessions to his American address, then he called the airline and changed his ticket. By lunchtime, he was climbing into a taxi on the way to the airport.

"Welcome to the United States of America," read the large sign above the immigration booths at the John F. Kennedy airport. The first people Alex and the other passengers saw as they stepped off their aeroplane were heavily armed soldiers. The airport was swarming with them. As he moved through the airport, the impression that the military were expecting some sort of divisional attack grew larger. Overreaction, thought Alex, but he kept that remark to himself.

"Hello, Alex," said a voice behind him in the line for immigration. Alex turned round. The man addressing him was wearing a safari suit with a pale yellow turtle-neck and white loafers. His hair was shoulder-length and he wore a large pair of dark glasses on top of a Zapata-style mustache. He looked like a successful Colombian coke dealer from the 1970s. He was standing with a smartly dressed woman whom Alex thought looked like a Texan.

"Hello, Simon. I didn't recognize you without your cigarette holder."

Alex and Simon were old school friends. Simon introduced his companion. She was called Ann, and she came from Los Angeles. They were returning from a short holiday in the Bahamas.

Simon and Alex had been in the same house at school. Even though they both lived in New York, they did not see much of each other. Simon didn't work. He had a private income and divided his time between New York and North Yorkshire. They shook hands and began catching up. Alex remembered the tall red-headed old boy with no name and described him to Simon. Simon recognized him instantly.

"Oh, you mean George Fookes!"

"Fookes, the one who was expelled for blowing up the junior common room?"

"Yes, the very same," said Simon. "He's a building engineer and moved over here a couple of years ago. He's doing very well. I'm not surprised you didn't recognize him. He was expelled one week into your first term. I bump into him now and then. He hasn't changed a bit. He's still quite crazy, you know."

So that was where Alex had remembered him from. Fookes was in the school photo that was on the staircase wall that Alex had trudged up and down most days for seven years. Fookes had stood out among the other pupils because of his red hair and tall stature.

Simon gave Alex a ride into the city. The route into town was held up by several roadblocks. Military personnel and state troopers scrutinized car occupants as they drove by. They pulled over those they did not like the look of. Fortunately, their town car had dark windows. The conversation returned to Fookes. His explosive exploits had become legend at school and Simon had Alex laughing in the back of the car recounting them. Ann was not as amused.

"What's so funny about this person who's done such dangerous things that could have killed you all? I don't think he sounds funny at all, especially at a time like this," she said.

Simon explained the bigger picture. "You see, Ann, it's not just about him but it's also about our rotten old school. St Peter's is the oldest school in England and it has such a low standard of education and poor caliber of pupil that in over 900 years of history, it has only man-

aged to produce one famous old boy. He was called Guydo, or these days, Guy Fawkes, and he was famous because he tried to blow up the Houses of Parliament in 1603. He was caught red-handed in the cellars underneath the Houses of Parliament surrounded by kegs of gunpowder. The authorities of the day sentenced him to death for treason and he was duly executed. Every year since then, on the anniversary of his capture, English people burn an effigy of him and set off fireworks. Except at our school, where we don't think it right to burn old boys, even if they were treasonous."

"Remember, remember the fifth of November, gunpowder, treason, and plot," said Alex and smiled.

"And you think that it's funny that Fookes sounds like Fawkes and that Fookes was expelled for blowing things up just like Guy Fawkes failed to do 400 years earlier?" said Ann crossly.

"Well, yes," Simon replied. "Fooking hilarious, in fact."

Alex could not help laughing. Ann looked disgusted with both of them and finished the journey looking out the window, saying nothing.

Alex was feeling tired by the time the car pulled up outside his house. The last half hour, with Ann sulking and Simon making poor jokes, had been stressful. He waved Simon and Ann goodbye, promising to stay in touch. He let himself into the apartment. Bamber and his cat were there to welcome him home.

The next few months were a time of change for Alex. The flat in London sold well in spite of the local ferals, and he was pleased to see his English possessions arrive in America. It made him feel more at home. He was getting

on with Bamber better than ever and when she suggested they pool their resources and move into a bigger place together, he agreed. Even she was surprised. They spent their summer looking at places, going away for weekends, and generally having a happy life, which was a new thing for Alex. The bombings that had terrorized the city seemed to decline over the summer. Even bombers take vacations, it seemed to Alex, though he kept that thought to himself. The bombs had killed many people.

"Why don't you become an American citizen?" asked Bamber, one day late in September. "You've lived here for years. You know you're losing your accent, don't you?" She smiled at him.

"No," said Alex. "I will always be an Englishman in New York. I don't want to become a foreigner. Americans are foreigners to us English, you know."

"And you are poor limeys to us," she replied. "And speaking of Euro-trash. . . ."

"I hate that phrase."

"Speaking of Euro-trash," she repeated, more firmly this time, "Myra. You remember Myra, don't you?" Alex nodded. "Well, she has invited us to Meez van Blootz's opening night."

"Oh," said Alex, not really interested.

"And guess where it's going to be?" Alex shook his head; he was getting bored. "It's going to be in and around the cable rooms on the Brooklyn Bridge." Alex was impressed. He had always wanted to see the cable rooms and to get access to a place like that in this day and age was something of a coup.

"When is it?"

"It's on Tuesday, November the fourth."

"I'll call Simon Cooper and invite him along. He loves that kind of thing." Alex reached for the phone.

Security was high around the Brooklyn Bridge that night. The authorities searched everyone with an invitation to Meez's show and closed the bridge to anyone without an invitation for the duration of the night.

Alex and Bamber met Simon at the start of the boardwalk that leads over to Brooklyn.

"Hello, Alex; hello, Bamber," said Simon.

"Hello, Simon," said Alex. Simon was alone. "I like your hat." Simon was wearing a too-small alpine trilby with a small feather stuck on one side. His mustache was more Stalin than Zapata and with his grey raincoat and black plastic sunglasses, he looked like an actor from a Mexican version of *The French Connection*.

They walked up the boardwalk toward the tower. It was a little chilly but there was lots to see. Meez had decorated the boardwalk with colored paper lanterns and large colored flags painted with Japanese text. There was definitely an Oriental feel, thought Alex. People rollerbladed by with drinks on trays. They walked past two camera crews interviewing celebrities on the bridge. It was a busy night. By the time they arrived at the tower, the three of them were enjoying themselves. They made their way into the cable room. It was smaller than Alex had imagined but still impressive. It had a high ceiling and above them were arrangements of large wheels and cogs that were used to twist the cable in the construction of the bridge. They bumped into Myra, who was looking excited and happy.

"Hello Myra," said Bamber. "Great location, but where's the show?"

"It's fireworks!" said Myra. "And they are all going to be red, white, and blue."

"How very Fourth of July. That is a very American gesture coming from Meez, a Dutchman," said Alex, who was thinking that patriotic fireworks were annoying and the least original idea in the world.

"Well, Meez thought it's a time when art and the nation should come together and celebrate the freedom of expression that exists in this country."

Alex, Bamber, and Simon looked blankly at Myra. Alex decided to change the subject.

"How did you get permission to have a fireworks show on this bridge?"

"Oh, Guido organized it for us." Alex shook his head, he did not recollect anyone named Guido. "Of course you remember Guido. He was the one at that party last spring who could not keep his eyes off Bamber. You know, tall, red hair with a goatee. Guido Fawkes."

"Don't you mean George Fookes?" said Alex. "Guydo Fawkes is someone who died 400 years ago."

"No, darling, I never get a name wrong." She reached into her bag and handed Alex a card. "Look, it says 'Guydo Fawkes, The Really Exciting Party Company.' Here, keep it, I have others." Myra smiled and wandered off into the party.

"Well, it would help if she could pronounce his Christian name correctly. Pronouncing Guydo as Guido would have the old terrorist turning in his grave. That is, if he ever had a grave."

Simon looked thoughtful.

"You know it is the 400th anniversary of Guy Fawkes' arrest tonight, don't you?" asked Simon.

"It is the fourth of November tonight, not the fifth, Simon."

"Actually, Guy Fawkes was arrested on the evening of the fourth. In England we celebrate the 'saving' of Parliament, which was on the fifth of November, 1603."

"Oh," said Alex.

"Alex, I don't think it's good that we have an old boy using the name of an older old boy, who was famous for trying to blow big things up."

"The Brooklyn Bridge is a very big thing," said Alex.

"Fookes is crazy enough to do something like this," said Simon.

"And it is the 400th anniversary."

"Are you sure?" said Bamber. "It seems pretty far-fetched to me."

"No, I'm not. But I still think we should look for Fookes and have a word with him."

"If we're right, he'll be somewhere beneath us, laying charges!" said Simon. "I think Alex and I should go down below and see if Fookes is about. Bamber, perhaps you should follow us at a safe distance in case there is trouble so that you can run back and evacuate the place."

"Just suppose you're right. He might shoot you both," said Bamber.

"Oh, no," said Simon. "He would never shoot an old boy."

The three set off on their small adventure. It was easy to find the door that led into the bowels of the bridge. It had a sign on it that said "DANGER. NO ENTRY." Simon examined the door. It had been opened recently. They entered and descended a narrow metal staircase. Bamber kept well behind them. It was darker and much damper

than above, but there were lights on. They climbed down a couple of flights. The bridge was alive with the sound of traffic and voices from the party above. At the base of the stairs there was a small antechamber and it was through here that they found Fookes. He was leaning against a ladder with a glass of what looked like whiskey in one hand and something that Alex could not make out in the other.

"Hello, Fookes," said Simon. "Fancy meeting you down here."

"Hello, Simon. How nice to see you, have a whiskey." Fookes did not appear at all flustered. He looked genuinely pleased to see Simon. "And who is that with you?"

"This is Alex. He went to Peter's as well. He was in the same house as us, but he arrived the term you left."

"Didn't we meet at the airport the other day?"

"Yes," said Alex. There was a pause as the three of them looked at each other. Three old boys on November the fourth. They sipped their whiskeys. "Are you really going to blow up this bridge?" asked Alex.

"You'll kill a lot of people."

"Yes, I am, but I always give a warning. I've never killed anyone with my bangs. In fact, the police will have had my warning for this little spectacular for three whole minutes now. I was expecting someone a lot less friendly than you to have come down those stairs to investigate."

"My girlfriend was killed by an Irish bomb twenty years ago. They gave a warning too," said Alex.

"I'm sorry," replied Fookes. "I blow up buildings, not people. New York is full of terrorists at the moment, but I am not one of them. I am just taking advantage of their presence."

Fookes explained in detail how he had mined the bridge. As he talked they realized that the bridge had gone quiet around them. No traffic sounds. No party noise. Bamber and Fookes' warning had done its job and the police must have cleared the area. Alex and Simon became quiet. They were both thinking about how to get out of there.

"Do not move! Armed police officer! Put your hands in the air," shouted the police officer who had emerged silently from behind Alex and Simon. He must have crept down whilst they were talking. His pistol was pointing at Fookes' chest and the hammer of the pistol was pulled back to fire. Fookes was very cool. He slowly raised his hands and spoke.

"Officer. Listen very carefully. In my hand I hold a remote control device. It has three colored signals. Red, flashing red, and flashing blue. As you can see, it is on red at the moment, which means that if I take my finger off this button we will all be blown to kingdom come. If it flashes red it means we have three minutes and if it flashes blue, which is my preferred choice, we have thirty minutes."

The officer was silent, thinking over the few permutations. "Remember, officer, you are not Bruce Willis in *Die Hard*. In fact, you are. . . ." Fookes leaned forward to read the policeman's badge. "In fact, you are Officer D.F. Richardson. Please do nothing foolish, Richardson, as I make my exit up this ladder." Alex, Simon, and Officer Richardson watched Fookes climb up the ladder he had been leaning against and disappear from sight into a service duct in the ceiling. "Maybe there will be a George Fookes Day every November the fourth in

America," they heard him laugh. The three of them remained still. And then something fell down the ladder on to the floor. It was the remote control device and it was flashing red.

"*Three minutes!*" Simon and Alex shouted in terror as they made a rush for the exit. Officer Richardson yelled, "Asshole!" and set off after Fookes.

They never knew they could cover so much ground in such a short space of time. They just reached the police line as the bomb went off. It was an enormous explosion that shook people to the ground and covered the area with a vast cloud of dust.

When the dust cleared, it was seen that the bridge was still standing. A cheer came from the onlookers.

The bridge was out of action for over a year. It never fell down. Officer Richardson chased Fookes across the bridge all the way to Brooklyn, but lost him after the explosion.

Alex married Bamber and Simon cut his hair and married a nice English girl from York.

In the following edition of the *Old Peterite* it was noted that Fookes' name was still present among the old boys, but there was no forwarding address.

Clam Platter Splatter

(Explosion)
JOURNAL ENTRY
August 20, 2004 (11:30 AM)

Another explosion. Goddamn it, one of my ceramic poo-
dles broke. Shimmied right off the shelf with the vibra-
tions. And I hand-painted that one. Little pink toenails.
The poodle, not me. The ex-poodle, I should say. Now,
sirens and screaming. More than normal for West 46th.
What the hell?

Jeez, it's getting hard to stay in this town, what with
the noise, exploding buildings, sirens, cop cars, ambu-
lances, weapons of mass destruction, and the what-have-
you. How am I supposed to stay my own beautiful upbeat
and cheerful self? Aspirin and Coke?

What's worse is I can't go anywhere, me being what
the newspapers and TV news call "a person of interest
to the police." Maybe I should be glad I'm not a person
of *considerable* interest. Sometimes they throw that
word in there and it tells you something big – you
know right away that person is "Suspect #1." The cops
actually said, "Do not leave town." Like out of an old
movie. They really do say things like that – the real

police brutality – having to listen to their cliches. It's exactly like TV. I kept thinking the whole time I was being questioned, under the hot lights, the two-way mirror against one wall: "copper," "flatfoot," "bull," "pig," "fuzz," "dick," but, of course, I said nothing. I maintained my beautiful manners and didn't give them the pleasure of seeing me break a sweat. A cool customer of interest to the police.

But now, the cops will be back. I have nothing to do with whatever the hell is going on. I am innocent!

The so-called evidence? The letters.

THE LETTERS

Mr Howard Johnson
c/o HoJo's Restaurant
201 West 46th Street
New York, NY 10036

July 1, 2004

Re: HoJo's Times Square

Dear Mr Johnson,
I have been a long-time fan of your restaurants and live around the corner from the jewel in your epicurean crown – the HoJo's on the corner of 46th and Broadway, touted as "The Landmark of Broadway" built in 1959. I guess you know when your own restaurant was built, what with you being Mr Howard Johnson!

Clam Platter Splatter

I heard a scary rumor that HoJo's Times Square is about to be demolished to make way for a high-rise. Is this true? Do you think Trump is behind it? The HoJo's is the only decent thing left in Times Square since the hideous "clean-up." We can't let them take that, too!

But, seriously, have you completely lost your mind? Why would you sell? Do you want some hideous thing like the World's Largest Reality Show Shop and Emporium to open there? Is the restaurant losing money? It does seem virtually empty most of the time – you need to draw those tourists. McDonald's is no better than you! Where's your self-esteem?

We (I will help) have to think of a way to save this honored New York institution. You are a visionary. Who, but you, could come up with the concept of placing a tasty eating spot over America's highways? No one, that's who! Mind if I say, "Bravissimo"? That reminds me, have you thought of expanding into the European market? I think Italy is ripe for your "World Famous Clam Platter." Is that your so-called "signature dish"? Dee-lish. Plus, I don't think the Italians hate us.

$17.95 might be high for the clam platter. Put "Atkins-friendly" or "Lo-Carb" next to it on the menu. How are the carbs for that one? Chubby people (as well as fitness freaks) want to know.

Your biggest (not size-wise, silly) fan,

Jean Biddle

P.S. I see our favorite destination is also called the "Landmark for Hungry Americans." Truth in advertising!

Mr Howard Johnson
c/o HoJo's Restaurant
201 West 46th Street
New York, NY 10036

July 2, 2004

Re: Fred Harvey Restaurants

Dear Mr Johnson,

I am mortified that I attributed the concept of the over-the-highway restaurant to you and must correct that mistake immediately. I have discovered that was Fred Harvey. Did he steal your idea?

Speaking of Mr Harvey, what'd you think of the MGM musical starring Miss Judy Garland called "The Harvey Girls" (1946) which celebrated the female wait staff of Fred Harvey's restaurants? Did you see it? That's the one with that "clang, clang, clang went the trolley" business. Have you ever thought about making a movie featuring your Times Square gals? Documentaries are popular right now – you could be the new Michael Moore. In restaurant-speak, strike while the griddle is hot! I know for a fact that there's a waitress at your Times Square locale that certainly looks like she's got a story to tell.

Speaking of documentaries, "Super-Size Me" is screwing McDonald's royale, so jump on it!

Please send your autograph and – dare I ask – your photo?

Sincerely,
Jean Biddle

P.S. I walked past HoJo's today and took a hard look at the drawing of the legendary Simple Simon and the Pie Man. What's wrong with that damn kid's neck? Is he straining to see the pies? I didn't know you were famous for pies – I thought it was all about clams and ice cream. Have you considered a clam ice cream? Combining the two? Use cookie dough for clams; I don't think anyone would want real clams in their ice cream. Well, maybe some seafaring types and "salty dogs." Do you have many customers who hail from Maine? Have you done any demographic surveys? These are all sound marketing practices. I am not selling anything new here.

Mr Howard Johnson
c/o HoJo's Restaurant
201 West 46th Street
New York, NY 10036

July 9, 2004

Re: hot dogs

Dear Mr Johnson,

Well, whoever said, "you learn something new every day" was a genius.

I took the opportunity to investigate the Howard Johnson's website. I am proud that you are so up-to-date and techno-savvy. And while there, I discovered a couple of things of interest. I have a question.

After you got famous providing the ever-hungry, semi-starving American public with twenty-eight

different flavors of ice cream, you branched out to create a new way to serve the old-fashioned hot dog. It says that by clipping the dogs on both ends, slicing notches in them, and cooking them in creamy butter that "infused the meat," you invented HoJo's so-called "elegant frankfurter." Is it the notches that make them elegant?

Maybe we could call the new ones "salty dogs" for the people from Maine, if my hunch is right. But, in any event, hot dogs are all-American. Everybody likes 'em! In these patriotic times of ours, proudly push the hot dog as a symbol for the all-American Howard Johnson's. Nobody is going to suggest destroying a symbol of America – nor the place it's cooked in!

You may want to make it a little healthier and eliminate the butter (or don't really but say you have), and maybe call its new incarnation "HoJo's Leaner Wiener."

Speaking of the "elegant frankfurter," I have an idea I want to run past you. Remember how in the theme song from the Patty Duke show, "a hot dog makes her lose control"? You should work that into your menu description. Don't make it sound like loss of butt control. That would be unappetizing to most diners.

Come to think of it, maybe Patty would consider being the HoJo's celebrity spokesperson. That is big in advertising (think Tiger Woods for American Express or June Allyson for Depends – stars mean giant $$$ profits). Do not use June Allyson – again, mixed message. I wonder if Miss Duke could be persuaded to play both identical cousins (typical American teenager Patty and the fancy Cathy from London – she does an excellent English accent). Bring in the Brits.

We could advertise, "Oscar®-winning actress Miss Patty Duke"... blah, blah, blah. That gives her authority. For all we know, a hot dog still makes her lose control. Perhaps you can find out.

Jean Biddle

P.S. I notice that Howard Johnson has a registered mark after its name. When I write you, do I need to use it?

Mr Howard Johnson®
c/o HoJo's Restaurant
201 West 46th Street
New York, NY 10036

July 19, 2004

Re: Internet opportunities

Dear Howard,

May I call you Howard? I hope I am not being too familiar and now that we are practically business partners, I feel silly being so formal.

First, a compliment. I went into HoJo's this morning (to get inspired!) and had a cup of coffee at the counter. I noticed that you were thinking "elegance" once again when you installed the gold-marbled mirrored squares behind the counter. Gives those hungry, harried patrons something beautiful to look at.

You know, Howard, Howard Johnson's are just as famous for their orange peaked roof (looks like a witch's hat – a witch with a flashy fashion sense, right?) and topped with the Simple Simon weather vane as they are

for their delicious dogs and clam platter. Why not add that to the top of the building? Imagine the publicity. Who's the architecture critic for the *New York Times*? Do you want me to research it?

Yours,

Jean

P.S. Back to the Patty Duke "concept": I'm thinking maybe we could update her image. Put her in a 'do rag and alter that hot dog theme song by setting it to a hip hop beat. Just a thought.

Mr Howard Johnson
c/o HoJo's Restaurant
201 West 46th Street
New York, NY 10036

July 25, 2004

Dear Howard,

Write me back!

I've been doing marketing research on the Internet. I just looked up a website for the first Howard Johnson's and discovered that you have only had ninety-three hits! In computer-lingo that means only ninety-three people have clicked on that. And that includes me (twice). We have to figure out a way to "drive more people to your site."

In spite of the fact that I haven't heard back from you (are you really that busy?), I continue to work on ideas to save HoJo's.

On eBay, I found "up for bid" a brilliant 1964 ad featuring a picture of the former megaphone singing star

and actor Rudy Vallee (everybody's favorite) carving a turkey and then a bigger picture of a delicious-looking plate of mashed potatoes with gravy, turkey slices, a mixed green pea/cubed carrot offering. The ad reads:

How to Succeed in Carving a Turkey Without Really Trying!

1. Put the family in the car
2. Head for the orange roof
3. Order Howard Johnson's Turkey Special ($1.49)

Well, that gave me a great idea. The Broadway tie-in ("How to Succeed in Business Without Really Trying") is perfect for your Times Square site! How about updating the concept? New ad campaign! Here's one to get you started – no charge:

Have a "Wicked" Good Time at HoJo's!

Yours,

Jean

P.S. I'm still waiting for that autographed picture.

Mr Howard Johnson
c/o HoJo's Restaurant
201 West 46th Street
New York, NY 10036

July 29, 2004

Howard,

You know, it's kind of embarrassing to spend the amount of time I have writing you and offering ideas (free) on how to make your restaurant even better and

Crimeways

maybe save it from the wrecking ball, and I don't hear a peep back. I thought we were working together. Anyone would be mad. I'm not one of those people to just act like everything's fine but secretly be all pissed off. Just so you know.

Have you ever looked at eBay? There is a ton of Howard Johnson memorabilia there. You could get a mint for the terrazzo tile floor alone plus the welcoming threshold with the HJ logo (is it from the thirties?). FYI, a small juice glass gets about $8.00 – how many you think you've got of those? Are the upholstered benches Nauga-hyde? Aesthetically speaking, I wish they were still in the original turquoise blue, but I still say they're worth some-thing. Put "Vintage" on them and watch the dollars roll in.

I hope I hear from you soon.
Jean

Mr Howard Johnson
c/o HoJo's Restaurant
201 West 46th Street
New York, NY 10036

August 1, 2004

I am only mentioning auctioning off the cool stuff in the restaurant in case something bad happens and you are forced to salvage what you can from the wreckage.

I better hear from you soon or I will think you don't care at all about saving HoJo's and that why am I bother-ing when the person it is named after doesn't seem to give

a damn. That would make you cold and remote and I hate to think of you that way when your restaurant is warm and welcoming.

J.B.

Well, that's it. The total and complete correspondence. Makes me mad all over again. I may as well have been spitting in the wind for all the good it did me. He never even gave me the courtesy of a reply, as they say. What a rude and money-grubbing man Howard is. But I just re-read the letters and there is nothing to suggest I would blow up HoJo's. I'm the one who cared about it, loved it, was trying to *save* it. Just because the owner wouldn't even lift a finger to implement any of my ideas or try to save that precious jewel doesn't mean I'd turn around and blow it up. Plus it blew in the middle of the night so just a few victims. Hell, with their crappy marketing, it could've blown at noon since nobody eats there, anyway. Maybe they ought to look at Mr Howard Johnson, Esq. himself . . . hifalutin greedy asshole. He probably did it for the insurance money.

Hey! That's a solid motive. Plus the way he ignored my letters, rather than indict me, shows that he could- n't care less. Any idiot can see that. Will any cop? I need to write to the cops. Of course, I have always had a high regard and the deepest respect for the "beautiful boys in blue." I need to fix that earlier entry about the fuzz. Perhaps I could help them with their investigation,

suggesting interrogation techniques, updating the "good cop/bad cop" concept. Who should I address it to? I wonder who is top cop.

(Second explosion!)

Bonfire of the Basquiats

Emerald van Winckel is famous for five things.

One, her name.

Two, her hair, which transcends all anti-red prejudices.

Three, her incredible posture.

Four, the size of her inheritance.

And five, her little-girl voice, which fools nearly everybody, including her bodyguard, Melchior, recruited in the wake of recent events. As far as Daddy van Winckel is concerned, Emerald is a priceless work of art, a jewel cherished far above the Basquiats and Warhols and Schnabels which line the walls of his Park Avenue triplex.

The kind of stuff that makes Emerald want to throw up, right now, as she talks on her cell to her best friend, Chelsea. They are discussing Emerald's seventeenth birthday party, two nights away. Emerald averts her eyes superstitiously as she passes the Grosz which looks like a demon fucking a goat. Or maybe a very weird Chow. She wanders inside the ballroom, where already people are polishing the floors in preparation.

"It's too bad about Fendi," sighs Chelsea. "It would have been *über*."

"Shit, I left my purse at school. . . . What?"

"You know, totally, to have it at Fendi?"

Chelsea talks into a void as Emerald turns to go find Melchior to ask somebody to fetch her purse. He's five paces behind her.

"Yes, I'm an absurd irresponsible child. . . ," she pouts. "Hey, babe, it's no big deal," she tells Chelsea, finally, twisting her waist-length hair into a lustrous red rope. "They're still gonna sponsor the goody bags."

"Oh, cooool. . . ." Chelsea's voice melts away, lost in a dream of buttery pelts to match her dirty blonde curls.

"And like they say," Emerald squeaks, "there's no place like home. . . ."

The girls fall silent in the fading light and, after last night's blackout, the lights twinkling in the awesome facades of uptown homes and offices look more heart-breakingly beautiful than ever. Emerald struggles with a clamor of conflicting thoughts, as if her mind were at war with itself. Beauty. Terror. The terror of beauty. And as she gazes out across the city, a shudder runs through her body, and the windows rattle in their frames, as a mammoth incendiary device detonates somewhere midtown.

Chelsea goes, "Fuck. Did you hear that?"

". . . kind of . . . felt it. . . ."

Then it hits her. She lets out a penetrating squeal of frustration. "Oh shit, now Daddy's gonna see it on CNN and ground me again. Ugh! Oops, I got another call, Chel, big kiss."

It's Edouard, of course. Third call today. Edouard with the cut-velvet voice, and the mesmerizing manner. He has this weird effect on her, though she would rather slit her wrists than reveal this to him or to any living being. She

feels almost drugged when she's with him, weak at the knees – something she thought was just a dumb novel thing, the kind with corsets and smelling salts. It's because of him that Daddy moved the party venue to the van Winckel residence, Edouard's suggestion. Enthusiastically endorsed by her father, who made calls straight away, batting aside her half-hearted protests. "He's right, baby – way too risky." She despises herself for being pathetic enough to succumb to Edouard's empty beauty, for being so tragically disappointed about tonight. At the same time, she's almost relieved they've struck again – on the very night she knows she would have been fated to surrender – they being the nameless, faceless, and seemingly motiveless assassins of art that are terrorizing the city. She cuts short the protestations of her eager suitor.

"Edouard, there's no way. I just know what Daddy's gonna say. . . ."

The bar's half-empty. Usually, it's standing room only at this hour. Edouard hangs up and winks at the barman, who winks back.

"Who's the lucky lady?"

"Ah, this one's a real number. . . ."

"Oh, yeah? I had me one of them, once. Table twenty-three." A subtle indication with the eyebrow. "Tiger lady."

"She wants it bad, and she thinks I don't know. . . . For fuckssake! Look at me!" An unlit Gitane droops from his lower lip, a brooding contrapposto Apollo in an English tailored suit.

Henry drinks it all in, times his response like a pro. "You're a good-looking guy, I'll give you that," he says,

picking up Edouard's diamond-head Dupont and lighting the cigarette.

Marek returns from the powder room, looking wild and gleeful. Lasciviously, he sticks his tongue through one of Edouard's smoke rings. . . .

"She's sweet, huh?"

"Sweet as a sugar-plum fairy," nods Edouard, popping a green olive into his mouth. "We have an appointment with destiny," he adds discreetly.

"Ah, le genius of le duc de Rothbart."

"I'll drink to that. . . ."

"You got the Vuitton trunk fixed up?"

"Special Edition Alexander McQueen model, Spring 2004," Edouard smiles. "Only five made. One for Madonna. One very specially customized for Miss Emerald van Winckel."

"Sure don't come more exclusive than that!" Marek does a drum roll on the bar top and slaps Edouard round the chops for good measure. "Operation Bonfire, we have va va voom."

They swig back their drinks before vanishing into the dead of night, to the luxury lairs where cultural terrorists go to pray to their gods of annihilation.

Three o'clock, Wednesday morning.

Emerald has followed Edouard's careful instructions, and managed to escape. Luckily, Daddy's in Milan till early Thursday; she'd never have gotten past him, but Melchior was easy. Dead to the world in front of the TV, twenty-four-hour news reports guiding the narrative of his tortured dreams. Now she is racing downtown toward SoHo, the wind in her heart, the cab cresting the ripples

in the asphalt like a shiny yellow stallion. Already she's wet between her legs. And the angel on her right shoulder is telling her it's not too late to turn back.

The devil dressed her. She's wearing a black satin La Perla corset, though she's concerned that the Gina thigh-high boots are maybe a little *trop* for a tryst. Encircling her tiny waist is the briefest pelmet of Anna Sui purple lace, as brief as the thought she gave to her puritan ancestry and dead mother before embarking on this journey. They pass closed-off areas beribboned with police tape. Downtown, shadowy forms lie stricken in blasted-out shop doorways, and for the first time since the Guggenheim, Emerald feels she has her nose pressed against the glass of reality.

Suddenly, she's there. She steps from the cab and glides like a black swan, head erect, to the somber granite portal of her defilement.

The champagne is waiting, of course, vintage whatever. Chilling. In Edouard's top pocket, the remains of a gram of pure cocaine sit in a Louis XV silver-gilt vinaigrette which belonged to his great-great-great grandmother, back in the heyday of the ancient regime. In Edouard's view, the Revolution was the end of civilization. *Absolument. Fin.* After Watteau, after Fragonard, after Boucher, there is nothing. No charm, no elegance, just the primitive barbarity of Picasso and beyond.

"Come here," Edouard commands, roughly pulling her through the doorway, biting her neck.

"You're late, bitch," he whispers.

She twists out of his grasp, offended, yet conscious of the fact that she can hardly play hard-to-get now that

she's here, in the middle of the night, dressed like this. Strange how almost, well, chaste, her ensemble seemed compared to the other girls when she wore it at a cocktail party a few weeks ago. Before the nightmare began.

Edouard, meanwhile, realizes his mistake and apologizes.

"I'm sorry, forgive me, my sweetest angel . . . it's just"

He seems to struggle to find the words. He does it well.

"I . . . I can't stop thinking about you. Tonight, I thought I would go mad with wanting you. . . ."

Chelsea's never gonna believe this, Emerald muses, wide-eyed. Like, nobody lays their cards on the table these days. Still, the sweet talk subtly goes to work, more potent than any urban cynicism she can throw at it.

"Champagne!" his chevalier announces suddenly. And with a flourish, he removes the bottle from its cooler, strips off the foil, and places it on a table. His movements are precise, efficient, and in spite of everything Emerald finds herself admiring his balletic grace. Inwardly, her heart pirouettes.

Edouard then unbelievably produces a saber, and before she can scream he has, in a brilliant flash of steel, sliced the head off the icy champagne bottle, which elegantly erupts onto the sublime patina of antique mahogany.

He can see immediately from her look of teenage awe that he has won. Inwardly, he congratulates himself. A supreme assassin of the female heart, he disdains the philosophy of absolute if transient sincerity at *le point* of penetration.

However, he must press home his advantage and enslave her utterly in order to carry out his instructions. He pours the champagne deftly, turns to her and takes her hand, tenderly now, kissing her inner wrist. The intensity of his gaze is hypnotic. She is half terrified, half in love, so much that she is deaf to the sincere declaration which accompanies the small velvet box he places in her hand. Within it, an emerald ring, courtesy of a Colombian drug baron who happens to owe Marek a favor. On the inside of the band is engraved the names *Emerald & Edouard*, binding them together . . . forever. Tears of exquisite joy prick her essentially schoolgirl eyes.

The twenty-carat stone rivals a *go* traffic signal in its size and brilliance, and has more or less the same effect. The answer is yes, and within seconds she is on her knees with his pulsating cock in her mouth, and he is fucking her lovely porcelain face.

The "Basquiat" cell which Edouard chiefs is one of the smallest in the city. Only three members: Edouard, Marek, and Melchior. Word on the street is there were twenty in the unit which took out the Guggenheim, including mercenaries. Other than such vague information filtered through junkie lookouts with limited life expectancy, there is no communication between cells. And no apparent commonality of motive. Some do it for money. Some for love or hate. Some for God. Some just for the motherfucking hell of it. But mostly God just about covers you, depending on your particular theological position.

Take Edouard. In his world the Supreme Being is basically Louis Treize thru Seize. Post-Seize is bad, albeit tolerable. Picasso to Pollock is a crown of thorns. But the

Crimeways

Anti-Louis-Christ of them all, the crucifixion, the ultimate guillotine of Edouard's private devotions – is Monsieur Jean-Michel Basquiat. An unforgivable stain on the nation of France. A commoner. . . .

And as for Marek: he doesn't give a two-faced fuck about George Dubya or the sugar content of Krispy Kreme Doughnuts, or American Abstract Expressionism, but he worships his sister, Vegas hookers, and Versace. Add to that a talent for smooth talk, an unshakable belief in the cheapness of human life, and a code of secrecy learned at his mother's breast, and it explains why on Thursday night he is standing under the canopy of the van Winckel residence guarding a giant box wrapped up in a froth of gold ribbons.

The doorman, who has seen it all, has gone to fetch a porter's trolley to transport the surprisingly heavy gift to the elevator. Guests flow past in a thin, condescending stream, glancing over their shoulders and smirking at the vulgarity of the object poised on the red carpet.

"Nice trunk, pal!" jokes a paparazzo, angling for a good shot. "Where's the naked lady? Hahaha!"

The doorman arrives back with the wheels. Marek bares his teeth insanely for the camera. He can't wait to get upstairs and into the thick of it. Feel the tension and smell the death wish in the air, because it's like that right now in New York. Everyone conscious of the dangerous proximity of high art, and the thrilling possibility that they could be in the right place at exactly the wrong time.

The elevator door pings open, and Marek and the trunk rise like a bubble into the firmament above.

Of all events in the terrorist calendar, the Bonfire of the Basquiats promises to be the most exclusive, Edouard

96

reflects with satisfaction, as he strolls the length of the ballroom, hung with the intolerable productions of the so-called Black Picasso. Nicky Hilton is here, talking hair with Kate Moss and Toby Young. Random combos like Donny Deutsch and George Soros and Gwyneth Paltrow. Niall Ferguson, Matt Silver, and Aimee Mullins. John Currin and Rachel looking great. Sean Combs posing with Jeff Koons. Lizzie Grubman debating courtroom etiquette with Martha Stewart and Johnnie Cochran. Anna Wintour listens, unsmiling, to Anthony Haden-Guest, already rumored to be writing a book about the guerrilla attacks.

Pausing to touch base with Chloe Sevigny, Edouard scans the room discreetly, recognizing Bret Easton Ellis, John Cale, Graydon Carter, Parker Posey, Jenico Preston, Moby, Richard Johnson, Harvey Weinstein, Mary McFadden, Fabian Baron, J.T. LeRoy, and new arrivals Steve Jobs, Terry Richardson, Cecily Brown in a see-thru dress. Van Winckel is talking to security while his pregnant wife of seven months makes eyes at Matthew Barney. Edouard takes it all in, moves into position, signals to Marek by the door as van Winckel mounts the podium and waits a few moments for the crowd to settle.

"My lords, ladies, and gentlemen," he begins. "As you all know, we're here to celebrate . . . the birthday of my beautiful daughter, Emerald Poppy Odette. Seems like only yesterday she was this high, but next thing . . . abra-cadabra! Whadda you know? I've got an *It* girl on my hands!"

Van Winckel, whose genius for making money invests him with a very special charisma, has always relished a

captive audience and, on cue, a ripple of appreciation dominoes through the room. Joke over, the speech takes on the presidential tone commensurate with Emerald's babyhood and early childhood, and as the autocue rolls on, the rate of camera flash diminishes to less than one per minute. The background murmur slowly dwindles. The flow of miniature designer canapés is halted.

The guests are almost grateful when the carnage begins. Everyone hits the floor screaming, except Daddy van Winckel, who cannot believe his eyes.

Melchior is in charge of preserving Emerald for the evil delectation of Edouard, silenced as he crushes her against a wall, ripping her scarlet duchesse Dior gown. Her abduction and subsequent disappearance is later to become a popular human-interest news item, providing an escape from the daily devastation. Melchior swiftly tapes her wrists and mouth as Marek and Edouard, armed with flame-throwing missile-launchers, target the monumental Basquiat series which lines the ballroom. Each man works systematically. They have exactly forty-five seconds to do their work. One potato, two potato, three potato, four. . . . Emerald, barely conscious, sees only a blur of flame and violent color as the canvases explode in a deafening duet of destruction, leaving blazing, blackened craters to mark their passing. As a grand finale, Marek, with the nihilistic cry of a warrior, takes out the giant, triple-height window at the far end of the ballroom. Bright daggers of reinforced glass slice through the night air like an angry, roaring manifestation of Zeus.

Then it all goes dark. Emerald is forced, in a bundle of torn satin and crimson tulle rags, into a Vuitton tomb.

Bonfire of the Basquiats

Her last conscious thought is a feeling of devastating loss as her engagement ring slides from her finger in the final assault.

His mission complete, Edouard nods to the others, and swiftly sidestepping the bloody corpses of three security guards at the main door, the three make their exit.

Fruit Cocktail

The explosion shook the building. I could tell by the sound that it was some distance away. It must have been a big one. As hard as I tried to pretend nothing was happening, the vibration in the floor and the brief flicker of hallway lights made me pause. I rang the doorbell of apartment 8B.

She opened the door with a flourish. From the way she was dressed there was no doubt of what I was in for. She wore a red-laced nightie, with a robe to match. Her face was painted like some wartime pinup. She looked younger than I had remembered. The stink of cheap whiskey came from the glass in her left hand. Cubes clinked as she took a step back and wordlessly invited me inside.

"Would you like something to drink?" she asked as I set my toolbox down.

The thought of her paint-thinner made me nauseous. Besides, I had been through this a hundred times before.

"I don't have time for that shit, baby," I said, reaching out and grabbing her tits. She didn't react.

"Either your faucet is dripping or your pussy is," I

said. "I think I can smell which from here."

She just smiled and stared at me like she had a secret. I got sore.

"So are we gonna play fix-it or fuck?" I demanded.

"I don't even know your name," she breathed, setting her glass on top of a dresser by the door.

"You know I'm the super. You know I fuck half the chicks in the building or else you wouldn't have called me up here in broad daylight with your undies on."

Now she laughed. "Yeah, that's right, stud, I hear you got a big cock too."

She turned away from me and walked over to the open sofa-bed in the middle of her studio. There were no sheets on it. She took off her robe, threw it on the floor, and tossed herself on the bare mattress. I watched her for a minute as she lay there waiting, not moving or looking at me. She was a hot piece, no doubt about that.

I bent down to take off my boots and noticed the light coming from under the bathroom door.

"You got someone in here already?" I asked, half-joking.

She sat up quickly. "No," she said sternly, then her face went soft again. "Are you gonna fuck me or what?"

I glanced back at the bathroom door, then shucked off my jeans and walked over to the back side of the couch. She got up on her knees and pulled my cock, half-hard, through the fly of my boxers.

"Not bad," she said, looking me over. Then she lunged forward and inhaled my cock all the way down her throat.

I grunted and looked down at her in a new light. I hadn't met many women who could take me like

that, at least not the starving married bitches in this building. She grabbed my balls and gave a yank, with one finger sliding up toward my asshole. I pulled off my shirt and let her take her time. She was very skilled, no question.

I would have figured her for a professional escort if not for her wormy little husband. I'd seen them pass through the lobby a thousand times, Elliot and Sandra Epstein of 8B. Him: a short, skinny four-eyes with a funny walk and a fondness for sweater-vests. Her: a hot piece of mid-thirties tail, looking a foot taller than her hubby and constantly running her chipped nails through her reddish-brown hair. Him: a professor somewhere in town, with a lot of weird, faggy friends. Her: a housewife in a studio apartment with no kids. No wonder she was bored.

I reached over her and pulled her nightie up around her neck. My right hand slid back down her torso, between her ass cheeks, with two fingers landing in sopping wet pussy. She lowered her belly, stuck out her ass, and pressed her face further into my crotch. Then she pulled up one leg, pushed it under my arm and curled onto her back so that my fingers never came out of her. I spread my legs slightly as she licked up under my balls, eventually digging into my asshole with her tongue like it was her last meal. Thinking of her husband, I had to wonder: who the hell did she learn it from?

One hour and seventeen positions later, with my cum still drying on her milky, blue-veined tits, I pulled on my socks and got ready to blow. She was sitting in a chair by the window smoking a cigarette, rubbing my busted nut in circles around her nipples. She practically

had her back to me as I opened the door to the hallway. I figured she felt guilty. I see that a lot. But right as I stepped into the hallway and pulled the door closed I heard it: what I thought was a loud sob coming from her bathroom. Fuck.

I'd been played like that before; this is New York after all. Jessica Martin in 5c had me fucking her up the ass while her girlfriend hid in the closet with a video camera. They showed it to me later and had a good laugh. But this was different, creepy. The hairs on my arm went up as I thought about that little husband of hers sitting on the shitter with tears streaming down his face.

Then I thought, fuck it. Maybe that's his bag – he's a happy cuckold or whatnot. Maybe Sandra learned to suck cock so good 'cause she had six guys a night climbing the stairs to fuck her.

I had enough to do that week that Epstein's sob didn't cross my mind too often. A few days later, Mr Goodale in 8a complained about a leak in his ceiling, so I went up onto the roof to check it out. The white porcelain toilet near the south edge of the roof didn't catch my attention at first. Since all this local insanity started, there have been a lot more interesting things to notice: columns of smoke drifting up into the sky, black helicopters circling low. And the sounds of chaos, glass breaking, gunfire, sirens, boots marching.

When I did notice the toilet, my first thought was that somebody on one of the upper floors must have had their toilet replaced. Maybe the last super was too lazy to carry it down eight flights. But that would have been four years ago. I would have seen it before.

The toilet had been set down facing east. Anyone who

sat on it would have a nice view, anyway. I walked over to it, lifted up the seat, and almost puked. The inside of the bowl was streaked with blood. It was dry, of course, but some of it was still red. I swallowed hard and got a close look. The marks were so strange: lots of little dots around the top with long drips running down into the bottom in some places. What the fuck had made that pattern?

I closed the seat and stood up. With some hesitation, I lifted the lid off the tank and looked inside. There was nothing. And when I say nothing, I mean nothing: no valves, no floater, no chain, no cock-and-ball, nothing. The tank had been gutted. I walked back over to the fire-door and thought about what to do, if anything. In the end I decided not to worry about it. There was enough crazy shit going on without trying to figure this one out. I dumped some tar on Mr Goodale's crack and left.

Nobody was leaving the building much, so I wasn't surprised when Sandra rang my buzzer the next day. Lots of my regulars had been seeking extra comfort lately. Sandra's hair was up in a twist and she was wearing a strapless cocktail dress, burgundy.

"Hi," she said. "I wondered if maybe you'd like to defile me."

Despite the memory of our last strange encounter, I felt my dick getting hard instantly.

"Come in," I invited.

She looked around behind me at my shitty basement and made a face.

"Nah, why don't we go up to my place," she said, taking my hand and pulling me out of my doorway. I resisted.

"I don't think so, baby. I'm not into sperming-up a man's old lady while he's sitting in the crapper sobbing,"

I said.

She whipped her head around to face me with a look I didn't like at all. But then she regained her composure and let out a little laugh.

"I don't know what you think you heard but nobody was sobbing," she said.

"I heard it loud and clear," I said.

She got stern. "No. Nobody was sobbing. Come with me."

I went.

She was rubbing my cock through my jeans and licking my neck all the way up the stairs, which made our progress kind of slow. By the time we got in her door I was ready to fuck her brains out, so imagine my surprise when I looked up from her tits and saw three of Elliot's faggoty friends sitting on her couch. They stared at us and said nothing; three skinny white guys with shaved heads, wearing black turtlenecks. All three of them pale and wearing thick, black-rimmed glasses over beady eyes.

My first instinct was to turn around and look behind me. Her bathroom door was still closed, light coming from under the door. I pushed Sandra away from me.

"What the fuck is this?" I asked, looking around at everyone.

Sandra quickly closed the apartment door behind me and then rubbed my chest.

"Relax. My friends were just leaving, but I wanted to ask you a favor first," she said.

"Why didn't you ask me downstairs?" I asked.

"Because it concerns them, too. It's no big deal. You have a van, right?" she asked.

I looked down at her, still stunned.

"Yeah . . . well, no, actually. It belongs to the building," I said.

"But you use it whenever you want, don't you?" she asked.

"I guess, but it's full of garbage and you can't really go anywhere in it. How would you get out of town with everything blocked off by cops and marines?" I asked.

"I don't need to leave town. Look, this is Douglas, Albert, and Michael," she said, pointing in turn at the three zombies on the couch. "They're grad students of my husband's. They need to transport some stuff downtown tomorrow for a thesis project. It's really nothing. Do you think you could help them out? For me?"

I was about to say no and get the hell out of there when one of the things on the couch spoke up.

"We can pay you $500," it said, carefully judging my reaction. "We can get you fresh fruit, too."

This queer had a voice that made me automatically clench my ass cheeks like a vice. But the idea of some fresh produce made me salivate. Was I really considering this shit?

"I don't understand. Most everybody in the building is afraid to open their door, much less walk to the corner and buy what's left on the shelf at Mr Chen's. Why are you so hot to go running around town? And where the hell are you getting fruit?" I asked.

The pasty in the middle piped up. "Our fruit source would not be of any use to you. As for running around town, it's very simple. We are to graduate in a few months. Our tuition has been paid and despite the state

of things, life goes on. Professor Epstein still comes to teach every day, and so we feel obligated to complete our projects as well. Can you help us?"

I stared at them long and hard. As stupid as it may seem looking back, I had no great suspicions about all of this that I couldn't explain away with my natural reaction to faggotry. The truth is, everybody was scrambling to survive on some level. Two weeks prior I had fucked old Mrs Gansevoort in 4F for a few cans of beans, even though I wasn't desperate for them at the time. I gave in.

"Okay," I said. "As long as we're not talking about a bunch of bananas smuggled into town up somebody's ass, I'll do it."

They looked at each other for a second, as though that was just what they were planning to give me.

"Thank you," one of them said, finally.

An hour later, the nance-patrol was gone and I was happily watching my cock slide in and out of Sandra's bright red snatch. After giving her a lecture about springing shit on me like she did, I tossed her on the sofa and proceeded to bang all of my anxiety right into her cunt. With one of her legs on my shoulder, I dumped a second load deep inside.

As I got dressed, she sat by the window and smoked just like before. Didn't even turn to look at me as I wiped my cock off on one of her throw pillows. I zipped up my jeans and carried my shirt over to the door. Then, as I stepped back into the hall and pulled the door shut, I heard it again. The sound from the bathroom was much clearer this time, maybe because I was half-expecting it.

Sandra was telling the truth. It wasn't sobbing I heard, it was laughter. Creepy high-pitched giggling to be

exact.

That night the outdoor buzzer to my apartment sounded. Without asking who it was, I hit the door button on my intercom. Stupid. I watched the lobby-camera monitor on my wall with a sudden burst of fear and adrenaline as two older guys in black suits crossed to the basement stairs.

I took my time opening up after the loud knock at the door, made them show ID through my peephole, the whole deal. There wasn't any question about who they were, but I was scared shitless and didn't want to show it.

"Okay, okay," I said, cracking my door open and standing in the jamb, "what's this about?"

The gumshoe on the left said, "This is about you, buddy," and then proceeded to make me lose any composure I had gained with my little stunt.

He rattled off my name, birthdate, social security number, my mother's maiden name, the name of the second-grade teacher I had a crush on, high school girlfriends (may those bitches rot), my grades at City College, and the name and apartment number of every woman in the building I had fucked, including Sandra.

"And to cap it all off, you let the crippled trannie in 1B suck your dick on at least three separate occasions," said the detective.

"I was drunk," I stammered. They smirked.

Then the questions came. Had I seen anything suspicious going on in the building? Did anyone have a lot of cut-up electronics in their apartment? Anyone carrying pipes in and out of the building? ("Just me," I said. The suit on the right snapped, "Don't get smart.") Finally, I gathered that they were keeping tabs on at least two of

the apartments that I "visited" regularly. Which ones? They wouldn't say. Maybe I was involved and maybe I wasn't. Maybe I'd start thinking with my dick and tip somebody off.

Toward the end of our little chat, they got quite irritated with me.

"You haven't seen a fucking thing?" demanded Righty. His hand was red, gripping his notepad like he was going to punch me with it.

I said the only thing I could think of. "There's a broken toilet on the roof with blood in it."

They looked at me like I was nuts.

Lefty said, "Try one floor down, asshole."

Shit. Sandra. Had to be.

"No, sorry. I can't help you," I said.

Righty let out a sigh and fished a card out of his wallet.

"Don't bother watching your ass," he said, "we'll be watching it for you. If you've got anything to say, call me." He tossed the card at me and it fell on the floor as they turned away.

"Anything else?" I asked, wondering if this was really over, amazed I wasn't being carted away for something. I bent down to pick up the card.

"Yeah," said Righty, whose name was actually Walter J. Smith, "if I ever catch you with your dick in my wife, I'll cut it off before you can pull it out."

They disappeared up the stairs.

Why had I kept my mouth shut? I guess because I didn't actually know anything. Nothing added up at that point. Plus I hated cops. Plus I wanted the loot and the fruit from the flute-playing fruits. Say that ten times fast.

At least I had a little warning.

My buzzer rang around five in the morning. I was awake but it startled me anyway. When I saw that it was Sandra at the door, my stomach hurt.

"You should have told me it was going to be this early," I said, pulling on my jeans.

She was wearing a grey trench coat and a matching hat.

"I'm sorry," she said. "Everyone's here and we figured it would be less dangerous to go at this hour."

She went upstairs to get everyone organized and I went out to the alley to get some of the trash bags out of the back of the van. I had tried to get creative back when garbage pickup had first stopped. Now everyone was just tossing bags of shit out of their windows.

Sandra came out a few minutes later with two of the fags, and asked me to move the van up near the door. I pointed out that I had only emptied the van halfway, but she said it didn't matter, there was plenty of room.

With the van pulled up by the alley stairs and the doors open, I only got the smallest glimpse of what they were loading inside. It looked like a sculpture of a guy sitting on a toilet. A toilet. Shit.

Sandra rode up front with me and the three fags rode in the back. I couldn't even see their heads over the bags of garbage that were still in the van.

"Where are we going?" I asked.

She looked at me and smiled. "Seventh Avenue and 42nd Street."

I backed the van out of the alley and onto 85th Street, wondering how the fuck I was going to get an unmarked van so close to Times Square at five in the morning with-

out getting stopped. As I shifted the van into drive, my heart skipped a beat. Sitting in an unmarked car across from my building were the two detectives who had visited me. I pointed them out to Sandra.

"The two guys sitting in that car came to see me last night," I confessed.

Sandra didn't ask me anything.

"Well, then, let's get the fuck out of here before they get wise," she said. I stepped on the gas.

Getting us downtown wasn't as hard as I thought it would be. It was the predictable obstacle course of looters, burning cars, and mountains of garbage. But there was usually some room to maneuver, even if it meant driving on the sidewalk. The whole time I watched carefully in the side mirrors for any sign of the detectives, but they never showed.

As we got a block or so north of Times Square, the streets became impassable, and we could see from our view down Broadway that there were soldiers, tanks, and barricades blocking off the area.

Sandra turned to me. "This is as far as you go," she said. "I want you to sit right here for five solid minutes, then just turn around and go home, okay?"

She started to get out of the van but I grabbed her arm.

"What about my money and my food?" I demanded.

She yanked her arm out of my grasp.

"You'll get everything you deserve tonight when we get back," she snapped, and slammed the door. My bullshit-detector was ringing loud. I felt cheated.

Once again my vision was obscured as Sandra and the brooding cocksuckers unloaded the sculpture-thing

and darted west down 48th street toward Eighth Avenue. I waited for thirty seconds or so, then jumped out of the van to follow them.

The four were carefully but quickly carrying the large white toilet-object to the end of the block. I hid behind the shell of a taxicab when they stopped to rest for a moment at the corner of Eighth Avenue. When they continued, they headed downtown on Eighth, so I ran to the corner to keep up.

As they proceeded down Eighth, I kept a block behind them, darting into storefronts whenever they'd take a break. At 42nd Street, they took a left and headed back toward Seventh Avenue. I ran to keep up. I was practically right next to them when I rounded the corner.

I dove behind some garbage out in the middle of the street. When I peered out from behind the bags I got a good view of what they were carrying, and got hit with a wave of surprise. The toilet looked to be a real toilet, maybe even the one I had seen on the roof. But the thing sitting on it was not a sculpture, it was the fish-belly white body of Elliot Epstein himself. He seemed to be quite comfortably seated on his throne, occasionally reaching out to the heads of his carriers to steady himself.

I began to follow them openly now; they had picked up their pace and weren't looking behind them at all. When they reached the corner of 42nd Street and Seventh Avenue, catastrophe, or what should have been catastrophe, struck in the form of eight soldiers in black fatigues. They came out of nowhere, running down Seventh Avenue, and knocked over the whole group without even breaking stride. If only one of them had

turned around to look. . . .

I heard Sandra let out a scream, and was puzzled for a moment as she scrambled to her feet to protect the toilet instead of her husband. Elliot was on the ground now, groaning and reaching out to one of his black-clad girly-men for support.

I tried not to puke, I really did. But when I got a good look at Elliot, it was impossible to control myself. I knelt down and turned away from the sight as my own vomit swirled around my shoes. Now, Elliot's funny walk and the patterns in the toilet on the roof made sense. It looked like a clump of spaghetti, or perhaps a small squid hanging out of his asshole. Disgusting, bleeding hemorrhoids, some of them eight or nine inches long, hung down between his legs and onto the sidewalk. I had thought Elliot was in the bathroom while I was fucking his wife. Clearly, he had been sitting in there much longer than that.

My shock and horror at the sight of Elliot's freakishly distorted anus nearly caused me to lose track of the whole group. The toilet was upright, and Sandra and the sissy-boys had carefully lowered Elliot back onto the john. They picked up the whole package and quickly crossed Seventh Avenue, proceeding directly to the Fashion Center Information Kiosk. The giant button and needle sculpture resting partly on top of the kiosk were just beginning to shine in the daylight.

I hid at the corner of 42nd Street and watched as the group carefully positioned Elliot against the wall of the kiosk under the enormous needle. One of the bald boys pulled out a disposable camera and quickly took several shots of Elliot. Then without warning, Sandra and the three gay guys began sprinting back up Seventh Avenue

at high speed.

It was only a matter of seconds before Sandra saw me. When she did she stopped, and a look of total fury formed on her face. Her three buddies continued on out of sight, but Sandra came straight over to me. Before I could blink she was in my face, with a small pistol pointed right at my guts.

"What the fuck are you doing here?" she whispered urgently. I couldn't say anything.

"You've got about thirty seconds to come up the street with us," she said. "Make any kind of move whatsoever toward those soldier-boys in Times Square and you're dead."

I got the hint. With her gun in the small of my back, we sprinted up to the corner of 43rd Street, where I could see the gay boys huddling in a doorway. Just across from us was the old blue-neon police department shack, now filled with military personnel and separated from us by large cement barricades that stretched across to the north corner of 43rd Street.

Suddenly came the deafening boom, and white light washed over my field of vision. The Fashion District Kiosk exploded across the street to the west as a white and orange fireball lit up the canyon of Seventh Avenue. Red gristle, which could only have been Elliot, splattered out eastward under the needle of the sculpture.

To my left, the troops in the square immediately sprang into action, darting about to find the source of trouble. None of them seemed to attach any importance to the five of us huddled in a doorway; there were a few other people in the street now.

As the black cloud of smoke and fire began to lift, I

saw that the huge steel button was creaking off of its perch. It landed with a sickening crunch onto the pavement. The giant needle fell away and all of us, including the soldiers who had crowded against the barricade, watched in amazement as the button remained upright on its rim and began rolling down the street.

The smoke rose quickly in the cold morning air, and everyone grew silent as our view became clear. The button picked up speed. An old woman in rags with a shopping cart stood with her back to us in the middle of the street. She was about to pick up a tin can as the button struck her from behind. Even from two blocks away we could hear a crunch and see the red spray. The button mowed her down and exploded her skull like a grape.

On it rolled, for at least another block, moving quite fast now. It struck the back of a smoking vw Bug and was launched briefly into the air, landing with a metallic ripping noise into the roof of an abandoned city bus. The inertia of the button carried the whole bus forward, made it look like the top of a huge piggy-bank. The bus reeled and slid sideways, its tires squealing as it headed straight for the eight soldiers who had knocked over Sandra and the toilet just moments before.

As the bus slowed around 38th Street, gravity caught up with the huge steel button. The sound of grown men screaming echoed back to us as both bus and button fell over sideways, grinding the eight soldiers into mush. The ammunition and weapons the soldiers had carried sounded like popcorn as it all exploded under the weight of the sculpture.

Under the din of soldiers readying themselves for action nearby, I was aware of the sound of heavy breath-

ing. Sandra and her friends, puffing with excitement. I looked at them. One of the homos snapped a few more pictures. Sandra was weeping, but with an enormous, almost-loving smile on her face. Though I was numb from head to toe I began to think of myself, and how to get the fuck out of there without getting shot.

"So," I said, looking for any kind of reaction, "I guess you guys really hate Oldenburg."

Sandra turned and stared at me like I had just farted in her mouth.

One of the fags piped up, "That's not an Oldenburg, you fucking moron."

Sandra looked down at the ground and then back at me, clearly deciding on my fate. She grabbed my arm and pulled me out of the doorway, marching me in front of her around the corner of 43rd Street toward Eighth Avenue. Suddenly she stopped, and I turned to face her. I looked down at the small pistol in her hand and then back up into her eyes. She lifted the gun up to my face and rubbed the barrel across my lips.

"Run," she said.

I ran. I never saw Sandra again.

The bitch had cheated me out of my fruit.

The Earth Has Been Disturbed

Mere sounds never used to break in on my pursuit of nothingness, but things have changed. One moment I was a mile under the ocean, watching a giant clam open and close in time with my breathing and the universe's. The next I was on my feet in the darkness of my room, deafened, breathing hard, my guard up against an invisible, unquantifiable threat.

When the noise subsided and the shock waves gave way to echoes, everything seemed ludicrous. I was standing ready to fight a ghost, a shadow.

The blast hadn't been an especially loud one, but it put an emphatic end to dawn meditation. I had plenty of time to sit and think in the usual way before I went to work.

The last few weeks had been disquieting. I was involved in the biggest clean-up operation I'd ever been hired to do; far too big for me to handle solo. Even if the Commission had given me the contract and asked me to assemble a team, the job would have taken months. It needed to be done quickly. Human remains were involved, and those are the dirtiest jobs of all.

My conscience was none too clean that early morning. I made a pot of ginger tea and sat looking out my window.

There were many lights flashing and sirens wailing: police, firetrucks, bomb squads, ambulances, all heading some- where south of where I live. I sat and thought about what I'd done down there in the pit. I thought about why I'd done it and which, if any, forces had moved my hand to conceal and misappropriate the Object.

The Object – I can't think of any other word for it – was the only thing that looked clean amid all the destruction and carnage. I was working waist-deep in raw sewage, blood, waste matter. The filth covered my white protective suit. I was a mud-man, a blood-man, and then I saw the Object shining through the horror. Nobody was monitoring the clean-up operations. I was trusted, all of us were. My reputation, if nothing else, was spotless. I grabbed, unzipped, stashed. The Object came comfortably to rest in the crotch of the suit. The bulge it made there didn't look out of place. We didn't go through metal detectors at the end of a workday. We handed over any jewelry, watches, and other personal effects that had escaped disintegration. Nobody with a conscience could want to keep those things. But I kept the Object. The Object was different. Nothing like the Object could truly have belonged to anyone.

People were talking in the apartments that surround mine. They were calling up their friends and relatives, checking, making sure everyone they knew was still alive. A lot of people in the city still react to explosions this way.

I was surprised when I got a phone call too. I spent ten years without a telephone. Now I am obliged to have one because of my job.

The man on the other end of the line sounded peeved that I'd made him get up so early in order to call me. "You the zen garbageman?"

"Some people call me that. I wore green and orange for ten happy years, but I'm no longer a licensed Sanitation Engineer. I'm not state-sponsored in any way. Clients request my services because of the way I now approach removal work. I try to help people. What can I do for you?"

"Let's say we're interested in an unscheduled removal you did the other day. We want the thing you removed."

A chill went down my spine. I felt as though I was no longer a human being but a bunch of wandering light-lines on some security-camera TV program. "If you can prove to me that whatever it is you're talking about is your rightful and legitimate property, then I'll see what I can do about getting it back to you. You've implied a group interest in the matter. What's the name of your business organization, please?"

"Stow the professional crap, streetsweep. Put the thing in a plain brown wrapper and leave it in the lamp-post marked E8302 in Central Park at three this afternoon. The hatch giving access to the wires will be open. Make sure no one follows you, and get lost once you make the drop."

"Two things: I'm not free this afternoon – which you ought to know, if you've been observing me as closely as you claim. You also haven't told me anything that would lead me to believe the alleged *habeas corpus* of the matter belongs to you."

"Do what I said, or we'll make things hot for you, zen garbageman."

He hung up before I could wish enlightenment on him.

I walked to work, as usual, bringing the Object with me. I considered putting it back where I'd found it, thought about turning it over to the Committee, for some survivor or next-of-kin to claim. The Object remained confined at my crotch throughout the day as I worked. It returned home with me.

The telephone rang as I came out of the shower. I was expecting more threats, demands, and crude ultimatums. Instead, there came the offer of another job, possibly a welcome distraction from the Big One.

The young lady had a pleasant voice. She told me she worked for an art organization. She said it as though it were no big deal, but the name she gave was that of a high-culture behemoth. The Dio Art Foundation's board of directors had put her in charge of finding a discreet solution to a problem that had arisen in one of the two galleries she supervised. I'd heard of those galleries. They contained perpetual exhibitions, two site-specific conceptual installations by a reclusive artist. I'd avoided both places, despite having been told I *must* go by legions of people who claimed they'd experienced immediate transportation to higher planes. The concept of immediacy bugs me.

"So you've been shut down," I said. "Whatever money-laundering scam your outfit had going is *pfft*. Sorry, but it's not my kind of job."

"You've misunderstood me," she said. "It's true we're closed to the visiting public, but it's only temporary, and strictly voluntary. The work lives on, in hibernation. Gallery visitors started complaining of sunburn-like rashes and hot flashes. There were nasty rumors of foot-

and-mouth disease contamination. Now the other tenants are complaining, in both buildings. Gallery walls are not adequate protection, it seems, from whatever is causing the . . . symptoms. We want to find an alternative solution to dismantling the art environments. I've been told you might be able to help save the Earth Room."

The Earth Room: a choice chunk of Manhattan real estate, a two- or three-bedroom apartment at least, inhabited only by dirt. Not dirt, I was often corrected, but earth: rich black topsoil, fertile humus, fragrant loam. The problem was that the dirt was making people sick. My new client described fainting spells, cramps. A few art patrons had vomited and experienced crippling attacks of diarrhea. Yet she, who spent more time in those galleries than anyone, remained unaffected. She told me that she loved her work, that she believed in it.

"All right," I said. "I'll come take a look. But it'll have to be after gallery hours." I told her about my day job. She said she'd be able to give me some white wine to help me unwind. She always kept some at the gallery, even though they never threw vernissage parties. I told her I'd prefer water or, if possible, ginger tea.

"That's funny," she said. "My name's Ginger, because of my red hair. And my last name's Thurston, so I guess you could call me Ginger T."

I thought about red hair as I scraped black crusts of blood and dried human flesh-paste off concrete and steel into plastic bags for burial, in accordance with Orthodox Jewish funerary custom. Since it was impossible, in most cases, to determine the faith or ethnicity of the deceased, all the dead got a blast of last rites from every religion. We're all one when we splatter.

What would a zen funeral be like? This koan distracted me for almost a minute. Then I went back to thinking about red hair.

The earth lay dormant. Ginger showed me a dimly lit room full of black dirt held back by thick plate glass across a doorway. She winced when I picked up a sample handful.

"Don't worry, I'll put it right back."

"It's not that. The piece conserves its own integrity. I just don't want you to get sick. In case the malaise experienced by certain visitors is more than psychosomatic."

She wanted me to see her other gallery as well. We walked through SoHo streets made to glisten darkly by a light rain. I already knew the building. There had been a temple on the third floor before SoHo real estate skyrocketed. Ginger jingled an impressive set of keys and we were in. She hit the lights. The Broken Kilometer was prime retail space taken up by brass rods adhering to the illegal metric system. The rods, Ginger explained, were not to be construed as inert brass pipe, but were in fact lines symbolizing eternity.

She went straight to a small fridge and took out a bottle of Pouilly-Fuissé. She popped the cork and swigged. I stepped over the imaginary velvet rope and strolled through gleaming conceptual art. I felt woozy and strange. My mind was not clear. Either the dirt, or the rods, or Ginger was having an effect on me. Then it all came together: I was having dirty thoughts. I was packing a rod for Ginger.

Ginger's red hair was not brassy and neither was she. Her flaming glory fell in soft waves to her shoulders,

which, I imagined, were as freckled as all the cleavage she was showing me under a man's blue oxford-cloth shirt.

There was no point in continuing my inspection. I turned around and went back to the section of the gallery reserved for art lovers.

Ginger, bottle in hand, hip cocked, said, "Wow . . . I've never seen anyone have such a strong reaction to the installation before."

She knelt before me, set the bottle down.

"Oh, god, baby – you're so hard. Jeezus, and you're enormous, too."

"I hate to disappoint you, Ginger, but that's not me you're stroking. That's the Object."

She gasped and pulled away slightly. Then she recovered and unzipped me. A moan escaped her lips as the Object's silvery length slid into her hands.

"Something I picked up at work," I said.

She stared at it in breathless fascination. She was fondling the Object.

I asked her if she'd ever seen anything like it, and she shook her head slowly. I asked her if she knew what it was for. She nodded as though hypnotized. She lay back on the floor. She hiked her skirt – look, ma, no panties – and showed me one possible use for the Object. She showed me twice. Then she was ready for the real thing.

For round two, I wanted us to go back to the apartment full of dirt to rut and rollick like a pair of mud-chimps. Instead, we wound up in Ginger's gallery-chick pad. She had more white wine stashed there. She also had some naughty undies she wanted to model for me.

We got busy with some sitting zen, with Ginger on my face. Then we tried kneeling zen-doggie. I wanted to

be a zen missionary for the culmination, but Ginger had other ideas. She smashed her chest down on the mattress, looked up at me over a freckled shoulder. She put her hands to her creamy cheeks raised so high and whispered, "Slam your rod in my dirty place, you filthy zen garbageman."

Afterwards, while she sucked on a hand-rolled cig and I was trying to get my breathing back in order, I told her I'd take the job and that I'd start the next week.

Ginger showed me her gratitude all over again.

When I was getting set to go, Ginger asked me if she could have the Object. Since I'd watched her in action with the thing, giving it to her made a lot of sense. But there was still too much I needed to find out. Reluctantly, I told her no, and stuffed the Object back into its hiding place.

Everyone in town is jumpy. A girl I know who does deep shiatsu told me she's never done so many neck jobs. "Everybody's always looking up at the sky . . . all the explosions, all those fighter jets going by. A truck goes over a chughole and 500 people go into third-degree cervical compression."

When my neck hurts, I drink ginger tea. Something Ginger and I had done together was making my neck hurt. I prepared a triple-strength potful and knelt with the Object before me. I tried to imagine what it really was, what it meant, who had made it, who it had belonged to, why others coveted it.

Ginger clouded my mind. Not the tea, but the artsy redhead. I tried to dwell on the serenity of red clouds – night or morning, delight or warning. I was looking

forward to doing the gallery job, to the prospect of working more closely with her.

Giving up on evening sei-zan, I let my mind drift back to my preliminary inspections of the Rooms Full of Dirt and the Busted Rod. The external factors first: SoHo was dead as an art scene, everyone knew that. The pseudo-permanent site-specific installations were therefore relegated to the status of relics, or fossils. Those terminally unhip art patrons who still shopped the SoHo art mall might have copped a whiff of corpse gas. Poor ventilation can cause soil to decompose. No earthworms in an art environment, no healing rain. But what about the brass rods? Why were they sickening the people who inhabited the seven-figure condos above them? Lack of polish? In my head, I saw an old black man whose weekly task it was to apply Brass-O to all the two-meter-long metal tubes. He stroked each one lovingly with a soft white rag and put it back down.

There was no serenity to be found in either place. Whatever quick-fix Nirvana may once have been there was gone. I knew I'd seen something wrong in both art spaces, but my deductive reasoning was distracted by freckles and a blue shirt left unbuttoned a notch too far. Fingerprints and palm smudges on the glass which held back the black dirt. A subsonic buzz in the hall of brass. Couldn't concentrate – red clouds, red hair, creamy flesh.

The telephone rang and I woke with a violent start. We who live in the city have learned to fear even the most banal sudden noises. I didn't want to answer, but it seemed unfair to let the ringing wake up my neighbors as well.

"You fucked up, zen janitor. We have this funny feeling you are not taking us seriously. We're going to show you we mean business. We're going to hit you where you live . . . gonna hit you hard."

I wasn't talking to the same person who'd made the first call regarding the Object. Obviously I had at least two enemies out there. "I never doubted your seriousness," I said. "The hour you unilaterally insisted upon wasn't convenient. I'll meet with you when I'm not working."

"You've already met us. There was a disagreement."

Whoever it was hung up on me. An unsatisfied former customer?

Some people in the city feel they need a man trained in Tao to remove certain things from their dwellings or their lives. Many aspects of urban life make humans feel impure, unworthy, soiled. The first job I did was for a female vegetarian. She was slim, blonde, in her thirties. Acting on an irresistible primitive urge, she'd glommed some fast-food barbecue ribs, her first meat in ten years. She called me in a panic, told me she couldn't face her morning-after bowel movement. She also felt it would be wrong to flush away evidence of murder. She was in tears, hysterical. She knew her meat mud-pie would haunt her forever.

I vaguely knew this woman. She'd knelt with me a few times at the zendo on Riverside Drive. She said she felt she could trust me in her most intimate and filthy moments. I went to her place. I talked her through it, held her hand as she squatted, catlike, over yesterday's *New York Times*. I worked origami around her offering. I got in the shower with her, applied soap to the areas,

cleansed, rinsed. We walked over to Central Park and gave her carnivorous stool sample a solemn burial under an ironwood tree in the dark recesses of the Ramble.

As soon as the ritual was over, she insisted on giving me vigorous outdoor public fellatio, in addition to two hundred dollars for the day. I thought she was weird, but she seemed so happy. I like making people happy, especially women. That's what we're here for; that's what life is about, as near as I can figure it. She recommended me to her friends. A month later, I took early partial retirement from the New York Sanitation Department.

I've cleaned out Collyer Brothers-style apartments for people concerned that dead grandpa or grandma might be stuck in the Bardo, chained to their bizarre accumulations of possessions.

I've stepped in for Asian small-biz families who couldn't afford to pay off private garbage-removal racketeers. Mobsters have a mystifying apprehension of men whom they suspect might be priests.

I'm no priest. I'm not a roshi, or even a monk. I'm a guy who likes to sit or kneel in empty rooms for hours on end. I enjoy mentally placing myself atop Everest, or in the middle of the Sahara, or at the bottom of the Marianas Trench. Some people are impressed by this. Some people are neurotic and have too much money. A man who is a lawyer asked me to get rid of a gun he'd bought to kill himself with. A young woman who works in advertising told me she'd dropped her diamond engagement ring down a storm drain following a heated altercation with her boyfriend. She wanted the ring back, without too much fuss. She said she knew I would find it for her. She bought me a wetsuit for the job. I located her

ring using the unaimed arrow principle. I went down into the sewer like that miner in Brazil who pulled a ten-kilo gold nugget out of a mud puddle after having dreamt about it. Kilo ... kilometer, gold ... brass ... I was drifting back into sleeping zen when it came to me. Nothing was wrong with those brass rods when I saw them. Something *would be* wrong with them. In my dream, the rods cast an unholy glow.

My anonymous telephone enemies caught up with me as I was walking home from the destruction site. I saw what looked like a crowd of prostitutes gathered around a garbage pile in the Meatpacking District. A pair of legs stuck out from under a heap of heavy-duty black plastic bags. A spread pair of legs encased in black fishnet stockings, coarse gauge; on the feet, red spike heels, size six.

The fishnets were a trap. I drifted in like a suckerfish. Someone sucker punched me with a garbage bag full of powdered cement. On my way down, I saw that the supine fishnet stocking wearer was a man. A man in a blond wig and a stuffed bra. He had hairy cleavage, vigorous five o'clock shadow, and exceptionally dainty feet. This trannie caveman slid out from under me and delivered a series of pointy-toe kicks to my crotch. Through training, I've subjugated all the involuntary muscles down there to my will. I was able to pull my testicles out of harm's way. I feigned unconsciousness as my assailants upended the contents of many garbage bags all over me.

"Welcome home, garbageman. Here, feast on these organic banana peels. Care for a used tampon? How 'bout some overcooked spaghetti, huh? *Huh?!?* Okay – he's cooled. Let's frisk him, girlies. Open season on package checks and other forms of sexual harassment."

I knew the voice. It belonged to Lester Frills, the self-proclaimed Pope of Black Zen.

Most people aren't made for a life of rigor. The pursuit of enlightenment through self-denial and sensory deprivation is a hard existence. Ego death isn't for everyone; certain individuals snap. Lester Frills snapped louder than anybody in zen history. He went over to the dark side of the material plane. The enlightenment he attained there was a baroque nightmare. He put aside his hakama and his rice-straw flip-flops, began dressing like a page from some florid fashion magazine. He went political, campaigned to have Art Deco written into the law books as the official style of New York City. Everyone in the zen community dismissed Lester as a harmless kook, a nut-job to be pitied and prayed for. Now he was going through my pockets, ransacking my person for the Object.

Before I blacked out for real, I wondered if the Object was some sublime forgotten masterpiece of Deco, the model for a skyscraper that would be yin to the Chrysler Building and Empire State's yang.

Fortunately, the unaimed arrow principle had led me to place the Object with a trusted friend, Winslow Bendix, a zen guy fallen on hard times. Floor Attendant at the World Show Center used to be a full-time job. These days, Winslow's lucky if they call him in two nights a week. There were other janitorial jobs available, but Winslow was sold on the Teh of mopping up human genetic material, slopping all that unfulfilled X-rated desire, all those potential human souls, or half-souls, down the drain. He uses no harsh detergents or solvents, only lemon juice and rainwater. He leaves a clean smell

behind him wherever he goes. The Object was safely stashed in a dark private viewing booth on 42nd and Eighth. I could retrieve it any time I wanted for the price of a peep-show token. And I knew Winslow could handle himself in the event of rough stuff.

I regained consciousness covered in decadent fruit and coffee grounds, feeling sore and slightly toxic. When I opened my eyes, all was white before me. In my animal terror, I couldn't appreciate the clean purity of that vision. I thought I'd been damaged, stricken blind. Then a breeze blew and showed me that the horrible whiteness was nothing more than a piece of paper which Lester, or one of his Black Zen boys and girls, had stuck to my forehead with a gob of spit.

The note, uncharacteristically for Lester Frills, was simple, understated, and crystal clear. It read, "Garbageman, Zen Minimalism is dead in this town."

It was a long walk home. I thought I might have a cracked rib or two; breathing was painful. There were other minor injuries – abrasions, contusions. I applied mercurochrome, got some ginger tea going. Then I got on the horn with Ginger. I was worried Black Zen might have observed our interactions, that they might try to harm me through her. But I didn't want to scare her.

"You haven't noticed roving gangs of insanely fashionable *incroyables* and *merveilleuses* following you around, have you? Or any Edwardian dandies behaving in a menacing manner?"

"Oh, Ziggy, you knew I was thinking about you and you called. I've been concentrating on what we did. You made me feel so dirty and yet so clean – inside and out, baby."

"I'm glad. Listen: did it seem like the door to your apartment might have been forced? Any windows open that you don't remember opening? Anything out of place in the toilet or kitchen? Were any mysterious parcels delivered to the gallery?"

"What are you going on about? I am sitting in my loft space, all alone. I am nude from the waist down. I can see my toenails. They are painted a pretty, glossy coral pink. I selected this particular lacquer because it matches my inner shade, Ziggy. I used a mirror at the Femasturbation Center to open my eyes to the inner me. I'm in front of a mirror now. My legs are spread so wide . . . for you, lover. My breasts are in a cut-out nipple bra under a light grey cashmere sweater, exposed and deliciously warmed. My new digital-video camera is on, and I'm rubbing myself down there. It's the art-school thesis piece I never dared to do. But now I'm doing it and you chose this moment to call. You've opened me in so many ways, Zig. I feel deeper, wider: as a person, as a woman. I need you to be . . . here . . . now, my zen garbageman lover."

"What you're doing is beautiful, Ginger. I'd love to be there with you, but I kinda got the crap beaten out of me on my way home from work."

"I'm penetrating myself with an object, Ziggy. In my mind's eye, the object is you."

"Speaking of the Object, Ginger, are you now, or have you ever been, a devotee of Black Zen?"

"What? Ooh, I'm cumming, Ziggy. I, Ginger Q. Thurston, am cumming."

She wasn't quiet about it, either. I had to hold the phone away from my ear. I was worried what the girls in

3G would think I was getting up to. After a quarter-hour, it seemed Ginger was done.

"You could come over here," I said. "I'll make us some brown rice and then –"

"I don't know, Ziggy. That was pretty intense. I think I kind of need to be alone for a while, have some more white wine, go through some slides, and crash. I'll see you next Tuesday, right?"

"Check."

Ginger tea did nothing for my hurt, but I didn't have anything stronger. When sleep finally came, I dreamt I was in that sewer again, mother-naked, no wetsuit, casting around for a lost diamond in a dark universe of human waste. This time I couldn't find it.

I spent the weekend willing broken ribs to heal. Monday and Tuesday I was in the pit, doing the work. After quitting time on Tuesday, I went to the Rooms Full of Dirt.

Ginger was behind her desk, reading a fashion magazine. She jumped up from her overdesigned gallery chair and wrapped herself around me.

"You're so zen and efficient, Ziggy. Your disciple guys got here just before lunch and they cleaned the whole place out. Not a speck left behind. They were using little make-up brushes at the end."

"What?" I looked around. The dirt was gone. Ginger and I were standing in an empty SoHo apartment.

"They picked up the Broken Kilometer as well. Their dump truck was so chic – matte black."

"What did these guys look like? Were they foppishly dressed?"

"Oh, no – grey robes, darling sandals. They told me

to meditate on the sound of one finger snapping. Was that your idea?"

"Sure, sure it was. I'm pleased everything went so smoothly, Ginger. I just wanted to check . . . you know, stay on top of things. I'd better shove off now. It'll all work out, I swear."

"The Dio Art Foundation has every confidence in you, zen garbageman."

I wandered around the perma-terrorized urban sprawl, searching for a black dump truck containing pilfered dirt and brass. I had visions of mounds of black dirt with gleaming brass rods sticking out like porcupine quills, or the detonation plungers on a floating mine. Cops were everywhere. They looked exhausted, demoralized; encircled and besieged in a Khe Sanh of the Fifth Dimension. My former colleagues in the Sanitation Department have worked tirelessly and more or less thanklessly to make the city at least *look* normal again. No piles of garbage, no mounds of dirt, no dump trucks anywhere.

I cruised a few nightclubs and braced overdressed types who had residual flashes of The Way in their eyes. I got blank stares, no leads worth thumping spleens over. I drifted down block after block with my eyes closed, listening, smelling, tasting the city for purloined, displaced site-specific conceptual art.

I was exhausted at dawn meditation. Worse, I felt filthy with the taint of vanity. I wasn't searching for dirt and brass out of principle, but out of professional pride. My business reputation was at stake. I also didn't want to look bad in front of my red-headed boner idol, Ginger. I didn't even want to think about how the Dio Art

Foundation would react to my failure. The wrong side of them is a bad place to be, I've heard. My morning search for the void was clouded with koan-like headlines on newspapers that would never see print. "Zen Garbageman Fails To Dig Dirt, Blows A Rod!" "Unaimed Arrow Pierces Zen Garbageman's Own Ass-Flesh!" "'In The End, I Found Him Unenlightening,' Claims Disappointed Carrot-Top Art Bombshell/Zen Garbageman Gal-Pal!"

Then I remembered a real headline splashed across a flesh-and-blood newspaper which thudded down on the sidewalk next to me, atop a bundle hurled from a truck by a burly teamster: "Mystery At Indian Point Reactor – Spent Fuel Rods AWOL!" So many random acts of petty terror these days. Perhaps some lab-coated technician had been as seduced by the fuel rods as I had been by the Object.

I was going to be seriously late for work for the first time. I was mentally debating whether I ought to forgo showering that day, or break principle and ride the subway downtown, when Ginger telephoned. Even her phone ring sounded chirpy and gay.

"Oh, Ziggy, thank you, thank you. It's all so beautiful."

"What is? What are you talking about? I couldn't find –"

"Your zen assistants had it all set up before I even got here this morning. The big one, with the gap between his teeth and the gleaming eyes – I think he said his name was Lester – explained your whole *feng shui* concept to me. I think it's brilliant. The new *gestalt* makes for a more forceful and powerful piece. I think the Dio Art Foundation will approve. I even think the artist will

approve, assuming we can get in touch with him. The new earth smells so rich. With the rods interspersed, the whole is glowing and vibrant. Do you think The Broken Earth would be good as a new title?"

"Ginger, listen to me carefully: Lester and his gang aren't still there, are they?"

"Uh, no. They left after a brief ceremony which . . . which seemed odd to me, quite frankly: not zen at all. Donna Summer on a beatbox?"

"I'll be there as soon as I can . . . to make my inspection."

Body parts and rubble would get sorted without me that day. I ran down to SoHo, shredding my rice-straw footwear. The day's retail therapy session had already begun. SoHo-goers were looking for shoes and jewelry, the consolation of material things.

Ginger was smiling beatifically as I burst into the gallery. On another day, judging by her healthy glow, I would have asked her if one of my unaimed sperms had found the mark. Almost all the buttons on her shirt were undone.

"Doesn't it all smell wonderful and organic? With a top-note of lavender laundry detergent thrown in for freshness?"

I sniffed. There was indeed an invigorating barnyard smell about the place. The black stuff strewn all over the pickled-maple floor looked familiar.

"Ginger, this is bullshit."

She looked miffed, hurt. "Conceptual art's not for everyone. Some people can only appreciate that which is merely decorative."

"With some horseshit thrown in."

"Well, they're *your* assistants. I imagine you instructed them on which purification process to use."

"I don't have any assistants, Ginger. This isn't my work. I meant what I said, literally. This stuff isn't dirt, it's fertilizer."

"Oh my god, no."

Using what remained of a sandal, I brushed some of the bullshit away. A metal cylinder was revealed. It glowed a sinister yellow-green.

"Jumpin' Jesus, Ginger. We've got to get out of here."

"My lunch break's at two. I thought we could go to Jerry's."

"No time for that. Run."

I grabbed her hand and nearly broke the etched-glass door down. It was slow going, with her in her spike heels and me in my ruined flip-flops. She was reluctant to leave The Broken Earth unattended. I yelled at all the milling shoppers to get out of SoHo as fast as they could. They ignored me, or laughed condescendingly.

The explosion was a dull, prolonged intestinal noise. Ginger and I turned and watched in helpless horror. A whole cast-iron building had been vaporized. A bilious bubble, resembling a thought-balloon in a real-life cartoon, rose toward the sky. A hot brown rain fell and covered us all.

The Upholstered Stump

Sometimes I can feel the building sway. Ever so slightly, when I'm lying in bed, I can feel a gentle, not unpleasant rocking sensation. One, two, three . . . stop. They say that it's the tremors from tiny earthquakes, that the city has them all the time, down here especially: we're right on a fault line. I don't care. I feel like I have an internal hammock that goes for a swing every once in a while.

I moved the bed around a lot before I got the perfect view looking out the window. I used to watch the homing pigeons on the roof across the way, or rather, I watched the guy who took care of them. I could see only the very tops of the coops, the way the shadows fell across them, the way the guy roamed around doing chores I couldn't decipher. I observed the chicken wire, the cheap pine and plywood. The blue sky behind them. But the pigeons are gone now and the guy with them.

My binoculars don't work well. My friends dropped them in the lake many years ago and one of the lenses is permanently obscured. I never lose hope that someday I might be able to get inside and clean it up. I imagine the stink of pond water, bits of algae perhaps, breathing out of the pried-open chamber like the musty odor of

excavations in the earth. If I were able to get in there with a bit of cloth and wipe away the film of dirt, so as to look clearly through the lenses again, with both eyes open, would I finally forgive my friends who ridiculed my loss and didn't value what I had held so dear? Meanwhile, I peer through the one good eye, hoping to catch something interesting, some bit of stolen drama from a window across the way. But really, nothing is as interesting as the whitewashed wall of the building itself, and the way the light reflects on it and changes the tint of the white.

There are certain times when I leave the relative safety of my bedroom cocoon. I pour water in the kitchen. There's a shocking jolt and spurt from the spigot when the water's been turned off in the building and the pipes are dry. People advise you not to drink the water, but unless it's obviously brown, it's hard to feel afraid. I always think it's such a luxury just to have it coming out of the tap, right here, and I can shut it on and off at will, most of the time. It's simply useless to call anyone when it's broken. I have a page full of numbers that lead to other numbers that lead to offices where no one is ever in. The names on the answering machines change with some regularity, so I have to assume that occasionally someone comes in and records a new message, but perhaps they do that from a remote location. It's possible, in fact, that there is no office at all, just a number and a greeting, and a beep. Dropping your message in there is like throwing pebbles off a cliff: you just have no idea where they actually end up.

I can see a number of important buildings in the middle of town from the window beside my kitchen sink. It's not easy because I need to lean deeply into the sink, and

the view is sometimes buried in layers of fog or smoke. I check to see what colors they are lit in, but you never know what's being honored or celebrated, since anyone can pay to have their own colors lit. I rarely go to that part of town anymore, and since it's such an uncomfortable stretch and a twist over the sink just to get the view, I tend to not think about it all that much. I'm more involved in my rationalizations for drowning the bugs in the sink: if they're alive when they take that centrifugal water slide down the pipe, can it be said that I've killed them? I've relocated them, I've evicted them, I've displaced them. Some people pick them up with a piece of paper towel and crush them in their fingertips, but I cannot stand the sound of their brittle little ectoskeletons breaking up and I prefer to not to touch them even indirectly.

There was a time when mice were a problem here. I don't know why I say they were a problem, as I've always been more or less dreadfully lonely and you would think that having any creature at all to share the apartment with would have been welcome. Especially a mammal, a furred mass of flesh like me, with a reassuring endoskeleton. I'm not even sure the mice really did bother me, or if I didn't simply object to them through training and education. I classed them in the category vermin, a threat to be eliminated.

After considering my options, I bought some glue traps. I didn't want the hinge and spring: I didn't want to confront split skin, damaged bones, blood. I knew that the slap of the trap springing shut would wake me up in the middle of the night, and I'd never be able to get back to sleep. So I bought glue traps, little plastic trays spread with a strong, colorless adhesive. In the middle of the

night, I was awakened by a high, sweet shrieking. When I switched on the kitchen light, I saw that the mouse had torn one of its feet off trying to escape the glue. He shrieked desperately. I turned off the light and returned to bed. After some time, I was able to ignore the noise and drift back to sleep.

When I got up in the morning, he was still trapped, still alive. He no longer had the energy to squeak. I didn't know how to kill him. I called some friends, made jokes about gassing him in the oven, or smashing his head in with a hammer. But I didn't really have the stomach for it. I put him in a brown paper bag and threw him out the bathroom window. He was light, and the bag was lofted by the wind slightly before it cartwheeled out of sight. I don't know where he ended up, or who might have found him, or when exactly he died. He was alive when I put him in the bag.

But I digress. That was a long time ago, and the apartment hasn't had any vermin for a while. I may feel some residual shame when I think of that bag suspended briefly in the air, but what was I to do? They carry disease. They breed. I hired a cat from a friend and he patrolled the place and kept the mice away. Eventually, I had to get rid of him too, but that's another story.

Although my living room is considered spacious, I spend as little time there as possible. The door to the hall opens onto it directly, and all the activity in the hallway makes me self-conscious and irritable. I hear the footsteps back and forth, the sound of keys in multiple locks like slot machines giving out meager winnings. Everyone bangs their doors shut and snaps the locks once they're inside. They all live alone like me, and sometimes I can

hear their telephones ring or even a shower running if I'm standing right outside their door. But I tend to keep rather different hours, so I don't often see my neighbors face to face. Rather like a blind man, I recognize them by their vibrations.

I take my walks late at night, and if the elevator is broken again, I use the stairs to get out. It's better that way anyway, since the stairs bypass the tiny garbage room across from the elevator on the ground floor. They keep the window there open to air out the smell of rotting trash, but it just lets the rats in, and late at night is when they are most active. These are large city rats, impervious to threats, and they frighten me. Nevertheless, I sometimes kick the cans just to startle them and then I run away.

All night long the trucks travel back and forth carrying debris. It has a certain sinister effect, taking place as it does under armed officials, but the process is well organized and therefore reassuring. The rhythm of their progress at regularly spaced intervals, laying down increasingly definite tracks of sand under their powerful treads in the slightly sulfurous night, inspires calm. I'd prefer not to produce identification in order to pass into another zone of the city, since all my papers are expired or invalid in some form, and I'm not sure what I might have done that I should worry about concealing. So it's best to avoid the whole situation and stay here where I belong.

I have my own invisible tracks laid down, favorite routes to private destinations. There are messages written on the streets that appear and disappear, signs, portents, reasons for hope. I always mean to capture them, to

assemble them in a catalog, like rare birds or weather patterns, but I have so little hope for finding meaning that I'm afraid to try. My progress through the streets is marked by the cairns of street signs, the lights telling me when to stop and go, for my safety, for the sake of orderly progress, for the clear differentiation of the two. When the walk signs were words and not symbols I assumed that the heavy thunk they made when you passed them was the sound of people being counted. I didn't realize it was just the words revolving in the mechanism. I'm embarrassed to admit how old I was before I was disillusioned on this point.

It's good to see the surviving trees on the street. One can hardly believe that they can breathe, particularly now. Of course, if they crowd or otherwise threaten some municipal structure, they must compromise. I've never actually seen a tree being cut down or removed, but I've seen the evidence, their stumps left in the middle of cement circles embedded in the sidewalk. There's no attempt to hide the fact: no one ever goes so far as to dig up the roots and pave over the spot as if nothing had ever happened. It was surprising when one day I discovered that someone had taken the trouble to memorialize the event, to transform it even, by upholstering the stump.

The job was done with care, the shiny red vinyl pulled tight and tacked down with hammered brass studs, not unlike a booth in one of the old diners that are now themselves a rarity. The fabric was precisely trimmed, the studs were shiny, it even looked slightly padded and comfortable, as if you might sit for a moment to get your breath, if you weren't too terrified

of breaking into tears in public and being accused of not being sane. That was really the most dangerous thing of all, these days: if you lost the autonomy and free passage of the certifiably sane, you were prone to all kinds of abuse. It was best to keep walking and confine your outbursts to private rooms if possible, or deposit them with authorized personnel when absolutely necessary. The problem was that grief has a tendency to express itself suddenly and without warning; at the feather touch of a memory or a glance, you'd find yourself running for cover somewhere, and in this town, there's really no place to go.

The amazing miracle, then, is that there was more than one stump. The stump had a fraternal twin, upholstered, however, in identical style. It had a more complex shape than the first, stolidly round, stump, which made it seem younger, more frivolous, possibly reckless. It had a silly cartoon talk-balloon swelling from its original girth. It was upholstered by the same mysterious hand, though, in the same meticulous manner.

My walks would sometimes take me to visit one or both upholstered stumps. They were small and low to the ground, so in spite of the way their deeply saturated red covers stood out from the acres of streaky grey pavement, they were sometimes difficult to locate. Perhaps it's my memory. How could it be so easy to lose something in such a small area? Both stumps were in the same few-blocks radius of each other, but sometimes I would go for days unable to find one or the other. Then they would pop up again, always a block or two away from the intersection where I thought they had been. Sometimes they were defaced with graffiti, but they'd reappear clean,

their red vinyl seats shiny, their brass tacks gleaming, the stumps seasoning nicely in the rain.

But the older stump, the mature stump, the original stump that had offered me hope and rest and even an ideal of solitude among friends, was vandalized one day. Someone took a knife, or some kind of blade, and slit open the fabric, revealing the small amount of vulnerable white stuffing inside. There was really no way to fix it without redoing the whole job, and the mysterious upholsterer seemed to have moved away. It could have been he who tried to repair the gap with a piece of black electrical tape, but it didn't seem like his work. After that, the stumps depressed me with their air of having been abandoned, and I lost track of the sillier, younger sibling altogether. I stopped looking for them after awhile. The disappointment overwhelmed me and I could feel the pressure of tears trying to escape, so I just kept walking, with my eyes focused just far enough in front of me to keep moving without hitting anyone or getting run over.

Everyone left town, if they could. They escaped if they had cars or friends with houses in the country. But I wanted to stay. It was difficult anyway, crossing all the zones, answering the questions, having to have reasons to move around. It was exhausting and there weren't enough reasons anyway. I didn't really need to go very far, I just wanted to keep retracing my steps. I wanted to walk my personal paths, the way a farmer might walk his land, tending my private fences. There, the key embedded in the asphalt at the intersection. Here is the drawing of a shark. There are the shoes on the wire. I looked for the stumps in vain. They seemed to have truly disappeared this time, and not even a hole in the ground attested to

their prior existence. I had misplaced them so often that I thought I must be mistaken. I began to feel as if I had imagined them. I walked the same blocks over and over, scanning the matte, nonreflective squares of sidewalk seam to seam without finding a trace.

The trucks moved back and forth for a long time, and I think sometimes they still move around at night, stealthily, although I don't know what they're carrying anymore or where they're bringing it. I don't mind. I feel encircled by metal that can't be rusted by rain or snow, by giant rubber treads imbued with enough petrochemicals to withstand the heat of the sun when it shines, and the men that drive are easily identified by their colors. There's some security in that.

If I'm too lazy to walk up and down the stairs or too angry and impatient to wait for the claustrophobic elevator, I don't go out at all. You can get some air up on the roof, but there's a strange communications contraption up there now that buzzes and sends wires out everywhere; it doesn't feel safe, and the tar simply melts in the sun, and it sucks at the soles of your shoes like glue and pulls my flip-flops off. Sometimes it's just easier to stay in bed, more predictable, except when the building sways. But as I said before, I don't find the sensation unpleasant, I even look forward to it, feeling, as I do, like a baby rocked in the treetops. The nursery rhyme, with its sweetly rhymed threat, doesn't worry me at all, and in spite of the pounding in my ears, which I assume is only my blood rushing around its own well-worn path and not the sound of anything irrevocably broken or split, I escape into sleep.

Flesh Station Octopus

Leaving Mystic always gave her a thrill. She'd never been given a twenty-one-gun salute as a send-off before, though. Nice touch – bang! boom! – she wondered what she'd done to deserve it. This time out, as Commander of the sub-fighter uss *Octopus* – known as the *Octopussy* because it was loaded with eight supercavitating torpedoes and an all-female crew – she was headed for the Puerto Rico Trench. One of the deepest submarine trenches known, the Puerto Rico extends on the outer side of the Antillean ridge from Hispaniola to the median part of the Lesser Antilles arc, near the Guadeloupe Islands. There, in the fifth deepest body of water in the world, 28,232 feet down, she would be exploring dense aggregations of octocorals on the many seamounts in the trench caves. Her expertise, developed while studying at Annapolis, was in coral colonization and deep coral ecosystems. Inadvertently, her cadette research had led to some surprising statistics about submarine combat – largely owing to the fact that females had an edge over their male counterparts when dealing with deep underwater caves. It had been discovered that females could remain extraordinarily calm and patient, waiting in the

deep caverns for months at a time. This time out would definitely not be a "three-hour tour." Commander Olga Smirnoff and her crew of 200 gals were going to stay under for six long months!

As the tug pulled the *Octopussy* out of the mouth of the Connecticut River and into Long Island Sound, her excitement mounted. She felt a surge of warmth spreading over her lower belly and she was reminded of her dear lovely Rien. Last night, she had disobeyed strict orders: she'd left her quarters to be with him one last time. His wet, drooling male hardness had plunged deep into her funky grotto and had executed many deft maneuvers, thrilling her to her molten core for a solid, throbbing hour. This bold carnal act had transpired in utter silence, though both of them wanted to scream, "Fuck me!" to all the waves and whales. Nor had they dared to turn on a single light to illuminate their lustful intertwinings – the Academy was strictly "lights out" after ten o'clock. A court martial was only one of the many punishments the Admiralty had devised for illicit sexual acts between officers. Commander Smirnoff longed for a sight-memory of her rock-hard lover's tight, highly trained, and masterful body. Instead, she had touch-memories of stroking his practically hairless skin, his thrilling erect member. Her female parts ached for him . . . if she could only manage to keep the flame burning!

The Chief of the Watch and Diving Officer Lt. Gina Ashcraft stood on deck to her right. Junior OOD Officer of the Deck and Conning Lt. Genny O'Neil, or "O" as she was called, was to her left. Commander Smirnoff felt powerful and brave flanked by these fine females. She

took a deep breath and glanced at the distant shoreline and then briefly at her watch. 5:29 PM: the red October sky was alive and running like a well-timed Jenny Holzer. Timing is everything in the Navy. In less than one second, she would give the command to release the tug, start up the propellers and head east, out and down into the dark Atlantic Ocean.

The transit route for the *Octopussy* was to parallel the Atlantic coastline via approved submarine sea-lanes until Florida. She would travel at a depth of 600 feet, at a speed of twenty knots. Nothing fancy: just a routine transit. Confidence was written all over Commander Smirnoff's face as she sat at the Control Room's navigation table. The Control Room was one of her favorite spots in the sub. It was rigged for red, with no white lights on. This prevented possible night blindness when using the periscope; also, in case of surfacing, the OOD and bridge lookouts could retain their night vision. It was here that Olga could exercise her real talents: operating in the dim eerie light with swift and intuitive command. Besides, it was a sexy spot. 10:45 PM: time for the Watches to be relieved, as was customary in the Navy . . . fifteen minutes before the hour. Quartermaster Second Class Michele Kelly pointed to a chart and gave the sub's position to the relieving Watch, Navigation Chief Petty Officer Paloma Schultz.

For Olga, it was time for some shut-eye. Her quarters were simple: a table, a reading lamp, a bunk fitted with the one luxury she allowed herself – red silk sheets – and a Thonet bistro chair that once was her mother's. She had brought along a small library, filled mainly with contemporary art and architecture books. She also had a

collection of photographs of coral forests taken by the underwater photographer M. Sandler, which she kept in a leather-bound photo album. She had only two novels with her: *Heartways* and *Futureways*. She now wondered if she had made a mistake in deciding to bring such a small selection of literary entertainment. *More time for fantasy*, she thought, optimistically. She undressed slowly, turned off the light and lay down. As she began to drift off to sleep, she marveled at the sensation of floating that sub life created.

0300: time to get up and make the rounds. Commander Smirnoff had enjoyed a good sleep. She was now preparing to review the position and depth of her ship and issue a new set of orders. She figured that they had cleared south Jersey by now and was looking forward to the chance to join some of her crew in the mess for coffee and fresh muffins. There, she found Yeowoman Second Class S. "Suzy" Gantner, a buxom bowplanes-woman who had just left Watch. She was drinking her coffee and poring over yesterday's *New York Times*. After the requisite salute, they sat in silence for some minutes, Suzy continuing to read. Suddenly, between gulps, she blurted to the Commander, "It was two acts: two jets and two towers. The jury decided Silverstein will get his double payment!" The commander was caught off guard and resented this informal delivery of information. Quickly, she gathered her thoughts and realized that this Yeowoman was referring to the developer of "Ground Zero." She had followed much of the competition to rebuild the World Trade Center site because her sister had been on one of the architecture teams selected to "brainstorm the bathtub." Her sister, an architect from Los Angeles, had

relayed detailed descriptions of the process, which often seemed more like a soap opera or a CIA operation than an idealistic pursuit.

"So, what does this mean for the site? More Freedom Towers, more wretched white lights in the sky?" the Commander demanded.

Yeowoman Second Class Gantner returned to the newspaper article to scan for answers. "It ensures that the Freedom Tower will be built, the rest of the article is mainly about defining occurrence and Industrial Risk; if the jets had struck separated by a standard interval of seventy-two hours, then it would have been two occurrences." The Commander wondered why it had to be seventy-two hours, and not twenty-four, or twelve, then went back to her consumption of muffins, hoping her hips wouldn't get flabby after six months at these depths. Commander Smirnoff did have formidable hips. She was blessed with a sturdy frame and sizable breasts. She looked as good in T-shirts as she did in brass buttons. Her hair was thick, black, and shiny; her lips were notably rosy. She also had a scar on her left cheek – the result of an Academy fencing tournament in 1999. The scar gave her a war-ready appeal, and she was proud of it.

As she continued to move through the sub, attending to her duties, she decided to check the specs on the supercavitating torpedoes her Deep Angel USS *Octopus* sub craft was carrying. "Tomcats of the deep" was written in dark bold typeface on the front of the manual. She had read it a thousand times. "Patrolling the oceans at over 1,000 miles per hour . . . launched from carriers, these sub fighters decide who really rules the seas! They can turn off their engines, loiter indefinitely, silent, undetectable.

They attack who they want, when they want." Commander Smirnoff was excited by this technology. She marveled at the genius it took to figure out that moving these large objects underwater at super speeds could be accomplished by using the very seawater that surrounds them. That seawater is made up of hydrogen and oxygen, and that hydrogen is the most energetic rocket fuel there is, that her ship had the capability to provide the nuclear reactor needed to separate the hydrogen from oxygen to yield the boost – just killed her with glee! But what was even more amazing was how supercavitating torpedoes could move around in a bubble of air underwater, almost never becoming wet. She had been trained in "straight shooters," an earlier version of the Shkvals (Russian Squall), but had no experience with the newly implemented guidance system. As she understood it, the new model was equipped with wing-like fins, which extrude from the fuselage and extend beyond the super-cavitational bubble. These fins cause some increase in friction and offer the benefit of allowing the supercavitational bubble to be steered. Steering is further aided through the use of thrust-vectoring on the exhausts of the rocket engines, much like those currently used on the F 22 and SU 37 fighter jets. The thrust-vectored nozzles direct thrust both horizontally and vertically, allowing much tighter turns and angles of attack, and assisting the fins in effectively steering the bubble. Machinist First Class Margaret E. "Ski" Kovalycsik was the expert on board. Commander Smirnoff made a mental note to have a meal with Ski as soon as possible.

0545: time for the Coral Group Report. Moving swiftly through the sub, Commander Smirnoff found the

marine biologists gathered in reduced number mid-ship. They had divided themselves into three focus groups. Doctors Rubsy, Licht, Gray, and Sexton, representing the "Sea Pen Group," stood at attention as Smirnoff crossed the oval lab portal. "At ease," Smirnoff quipped, moving in a circular rotation, as the doctors continued on with their larvae free-float experiments, which they had set up to determine what factors allow larvae to exist away from seamounts. This was of particular interest to Smirnoff; she loved the idea of independence given to any form.

The second group, the "Sea Fans Group," reported that the forest of "bottle brushes" on board were particularly happy. These tree-like octocorals have a central axis made up of an array of skeletal formations called sclerites and are often augmented by horny organic substances known as gorgonin. First Class Eugenides pointed out the firm skeleton and perky branch network to Smirnoff. "And look – a healthy crop of polyps!" she exclaimed. Most octocorals have large, erect bodies that extend upwards into the water. Their size is instrumental in helping the polyps capture food from water as it passes by the colony.

Although Commander Smirnoff played a vital defining role in determining the scope of the experiments to be mounted, she had lost some of the pleasure in the process of detailed lab practice and observation. As she entered the third lab station, belonging to the "Soft Corals Group," she found Dr. D. Childs standing with a confounded look on her face. "What is it?" Smirnoff asked, a little annoyed by the lapse in formality. "Dr. Blake has just determined the age of our Class Anthozoa," Dr. Childs responded, "It's rather impossible,

but the molecular analysis has shown that the levels of isotopes are of equal measurement in all our 'creepers.'"

"Dr. Childs," Smirnoff asked calmly, "which lab did the clavularia specimens come from?"

Dr. Blake interrupted with a low ancient voice that alarmed Smirnoff. "They are from the Darling Marine Lab, University of Maine, Commander."

"Make a report and have it to me in twelve hours. I want to have this explained before we hit Maryland." Smirnoff gave Blake the once-over. She had a ghostly presence, but her Victorian hairdo was even more disconcerting. Add the voice and Smirnoff decided they needed a real makeover in section six, the mid-sub "Soft Corals Group."

Smirnoff knew that coral larvae are weak swimmers. That's why she so preferred the set of experiments by the "Sea Fans" to those the other two groups had planned. She herself had always been weak in swimming, always came in third place at competitions. Her hometown high school team, the GoCubs of Orono, Maine, were state champions. She had been the proud captain of that team, but the fact that she always came in third plagued her to this day. Over the years, she had rationalized her performance, preferring to think of the importance of endurance and using the example of coral larvae and their potential to remain in the larval stage for an undetermined duration . . . it could be weeks or months before they found a place to settle. For Smirnoff, third place came to signify potential. In addition, Smirnoff was interested in the "Soft Corals" early findings because some corals can live to be 100 years old. Could it be that the *Octopussy* was carrying a population produced purely

locally? Meaning that no new larvae had found their way to the core specimens in a century! More amazing than a Dia installation! That beat the Broken Kilometer and the Earth Room by fifty years!

0645: Smirnoff was back in the Control Room. The new Watch, Lt. Jan Mendoza, saluted and gave the ship's coordinates – just off Chesapeake Bay. Feeling ready for some meditation time alone, Smirnoff decided to head back to her quarters. On the way out, she noticed through the red glare of the room the bold typeface: "Tomcats of the deep." The supercavitational manual had found its way onto the Control Room table. It gave her a funny feeling. Why did they have a full load, anyway?

While resting in her quarters, Olga Smirnoff's thoughts drifted back to Rien. She quickly developed a feverish mental picture of her fellow-officer/lover masturbating as he recalled last night's heated, secretive love-making session. She wanted him to stroke the virile organ she had so recently devoured and incorporated, wanted him to do so in utter silence and deep-sea darkness. She felt the girthy circumference of Rien's prick in her hand again, a fleshy phantom. She opened her mouth, spread her legs . . . for nothing but her own roving hands, however firm their command of the present situation. She loved to pat her own bunny in the womb-like confines of her ship, the *Octopussy*. The *Octopussy* was her pussy – long, hard, and wet all over. She loved her ship. She loved her pussy. She loved Rien – his body, his cock, his whole all-Navy being. Maybe he'd be slightly less gentle with her next time. . . .

Just as she was coming. . . .

"Commander Smirnoff, Commander Smirnoff!" She became aware that someone was knocking on her door. Quickly regaining her wits, she jumped up and opened the door to find Navigation Chief Petty Officer Teresa von Bonin presenting a solid salute. "At ease," Smirnoff responded. She then was handed a blank piece of heat-sensitive official Navy stationery. Officer Bonin also provided a small laser pen and exited swiftly. Holding her breath, Commander Smirnoff began Procedure ss 472, which yielded newly issued operational orders by Task Group Alpha:

Deep Angel uss *Octopus*

Proceed to Hudson Trench immediately.

Position status: Undetectable (including all active Sonar and Fathometer devices).

Smirnoff pressed the laser to level four and the paper ignited. She headed back to the Control Room and found Mendoza giddy with anticipation. She had relayed the communication to von Bonin, so she knew something was up. Smirnoff commanded Mendoza to reroute the *Octopussy* to the Hudson Trench. "Reverse direction, speed set at twenty knots, depth 500 feet . . . oh, and Mendoza, don't forget to account for the Gulf Stream advantage: twenty knots could become thirty in a hurry."

"Aye, aye, Commander."

Mendoza was soon a-blur with activity. Smirnoff was feeling quite excited herself. Without incident, the *Octopussy* made a graceful U-turn and was on her way back to New York. Maybe it was going to be more like a three-hour tour after all, thought Smirnoff, but it definitely would not be tropical. Glancing at her watch, she realized they would be in the Hudson Trench within five

hours. She knew little or nothing about the trench. She assumed that it had been formed in times of low sea levels, like the Amazon and Ganges, and had been more recently modified by turbidity currents like landslides of sediment and dense slurry water. Octocorals definitely would be sparse. What could they possibly want with the *Octopussy* in the Hudson? She had a sinking feeling that her mission had been permanently altered.

Commander Smirnoff was accustomed to waiting. She had been trained to be patient and obedient. She assumed the next orders would arrive once she reached the Hudson Trench. In the meantime, she would have a chat with Ski.

Machinist First Class Margaret "Ski" Kovalycsik was able and ready to offer precise details to Commander Smirnoff. She impressed the Commander with her bright eyes and stunning intelligence. Her capacity for relaying complicated details of the supercavitational system was admirable. Smirnoff now felt ready for anything. She decided to return to her quarters and spend some more time meditating, and maybe even get some shut-eye. Before settling in, she would ask Officer Lt. Ada L. Huxtable to access all files concerning the Hudson Trench and to report to the Wardroom in one hour.

Smirnoff often started her meditation sessions by reading. She found the writings of Le Corbusier to be especially effective for focus. She had brought with her *The City of Tomorrow*, a favorite because of its grand propensity for mixing fact and fiction. She opened to chapter thirteen, "The Hours of Repose," to the dog-eared page entitled "Freedom through Order." Here,

within the context of town planning, her beloved Corbu explains how "Cells," as consequences of our social ordering, may be logically conceived and ordered to attain freedom. Smirnoff found the relationship between coral colonies and modernist fantasy a total turn-on.

In the Wardroom, Smirnoff met with Lt. Huxtable to learn the principal defining structures that make the Hudson Trench. The report was a surprise to Commander Smirnoff. The existing caves were numerous and the network extensive; it spread from the tip of Long Island through New York City, and up to Albany. This was obviously not an organic system of caves and trenches. "How many caves are there?" asked Smirnoff. Huxtable, who was a capable on-board senior, replied with a sly editorialized slant, "Only 472, Commander," she added, "of pure stiff sludge."

"That will be all, Lt. Huxtable. Report back in one hour with a more detailed cave quality analysis," Smirnoff quipped.

"Yes, Commander," Huxtable retorted as she sauntered off like a swaggering Mae West in *I'm No Angel*.

This was dizzying news for Smirnoff, who felt less and less able to anticipate orders. She had no idea what to make of this development. With a quick turn of her heel, Olga Smirnoff marched to the Control Room to get a dose of confidence and the exact location of her ship. The Control Room offered her its glowing comfort when she arrived. With a deep breath, she positioned herself at the controls and calculated the time remaining until entering the Hudson Trench network. She estimated that they were closing in faster than they probably should and at a dangerous depth for such speed. "Damn it, Mendoza

– I told you to watch that Gulf Stream!"

Because they had been unable to use keel-finding devices, the *Octopussy* would be in danger of hitting bottom. Smirnoff turned on the Fathometer momentarily to get a reading. *Just one 'ping'*, she thought; that would be enough. The chart showed only 400 feet of water under the *Octopussy* and the bottom was approaching rapidly. Smirnoff switched to continuous run and then to medium range. The bottom was still coming fast. Smirnoff ordered: "Full rise on both planes." Yeowoman First Class Brigitta Oslund bobbled the yoke joystick. Trainee Yeowoman Second Class Erin Slade reached in and pulled the bowplanes' controls to full rise. Smirnoff registered the 35° rise angle up. Oslund switched to shallow range, which switched to 'scope view. Smirnoff screamed, "Twenty-five feet till bottom! All back full! Don't ring it up, I need speed!"

Machinist First Class Margaret "Ski" Kovalycsik was chomping at the bit, shouting, "You want me to blow? You want me to blow?"

Smirnoff yelled, "Not now! There's a fucking fleet above us! Where did it come from? Mendoza! Zero degrees on both planes!" The *Octopussy* leveled off at 150 and proceeded back down to 200 feet, leaving a comfort zone of 200 feet below.

"Mendoza, I want a full report immediately, in my quarters."

"Yes, Commander, right away."

Smirnoff shouldered her way out of the Control Room. In her cabin, she straddled the Thonet and propped her jaw on her wrists. The knock on her door was loud and intrusive. "Yes," Commander Smirnoff

Flesh Station Octopus

answered.

"Interior Communications Watchstander First Class M. Fung reporting."

"Come in," Smirnoff replied.

First Class Fung handed her new orders. Smirnoff saluted and shot her a grin that made the young girl shudder. With a wave of her hand Smirnoff dismissed Fung and sat down. Realizing she had neglected to get the laser pen, she threw the door open and chased down First Class Fung. "I need the pen, Fung," she gasped. Fung fumbled in her breast pocket and in the process dislodged a shiny brass button; it fell to the sub floor with a loud ping. "That's one ping too many," Smirnoff whispered, stepping on the rogue fastening device. Smirnoff followed Fung back to the Control Room, hesitating near the ballast tanks to extract the orders and ignite the paper. She quickly read:

Deep Angel uss Octopus
Proceed to cave LMDC 1101.

In the Control Room, Lt. G. Ashcraft sat at the lighted panels in full concentration. Smirnoff's entrance caused her to jump and salute simultaneously.

"At ease, Gina. We have new orders to proceed to cave LMDC 1101."

"Aye, aye, Commander," Ashcraft replied.

Smirnoff was relieved to find Ashcraft on duty. She felt comfortable with her at the controls. "Course set for LMDC 1101. We will arrive approximately in fifteen minutes. Shall I introduce sequence 642, Commander?"

"No . . . not yet. Give me a countdown starting at two miles," Smirnoff said with a note of resentment. Being on a need-to-know basis always pissed Olga off.

159

She was at heart a full-on control freak – getting orders without a big picture was frustrating for a woman of her talents.

"Commander, we are within two miles of the cave's entrance. I am initiating countdown. Nine . . . eight . . . seven . . . six . . . five . . . four. . . ."

"Start Sequence 642," ordered Smirnoff.

"Aye, aye, Commander: initiating Sequence 642. Three . . . two . . . one! We are entering the cave! All systems in order and operational."

Smirnoff could not have enjoyed the adrenaline rush more. She loved caves, no matter where they were.

"Positioning central to cave right wall," Ashcraft reported. "Commander, we are not alone in this cave."

"What is it, Ashcraft?"

"I don't know . . . but it's a lot of . . . something."

Smirnoff dove upon the periscope and nearly fell as she recoiled from the blinding light that hit her eyes. "What is it?" she wondered out loud. Using a human iris adjustment technique that all the cadettes at Annapolis learn, she gathered herself and peered into the 'scope once more. This time she was able to see with reasonable clarity. It was some kind of construction site. Huge amphibious machines equipped with the latest technologies, a hundred glaring lights and hundreds of divers working on building . . . something. The divers were wearing US Navy-issue wetsuits – this she could see – but the machines bore no identifying codes. As they slowly worked, the machines, silhouetted by the heavy light, looked like huge, sea-dwelling dinosaurs. There was no acknowledgement of the presence of the *Octopussy*; this perplexed Smirnoff. It was as though they knew she was

coming . . . but it was against regulations not to signal. The *Octopussy* was supposed to be in undetectable status, true, but surely she had been spotted. OOD Genny "O" was now in the Control Room. Her female intuition led her to believe she was needed at Smirnoff's side.

"Officer O – signal twice, blink four slow," Smirnoff commanded.

"Aye, aye, Commander."

But there was nothing. No response. "Wait, Olga," Smirnoff whispered. "Wait."

"We are in holding float, level, and stable," reported Ashcraft.

"Good. Hold position, steady and silent," Smirnoff sounded in a solid, yet hushed voice.

Smirnoff slid off the 'scope and turned her attention to her crew. She was calm and studied. Although the mission had been diverted, she loved being presented with a challenge. Waiting for the next set of orders would be most difficult. In the meantime, she did have a lot to consider. Whatever was going on in this massive operation was deadly serious. She hiked herself back up to the 'scope for another peek. "OOD O – get over here and look," she insisted.

O, blinded at first, was on second attempt locked in, incapable of pulling herself off the periscope's viewfinder. "What do you think, O?" demanded Smirnoff.

"I . . . I . . . wonder where James Bond is!" she giggled. All the women on the bridge responded in kind, with that kind of repressed church titter that is so delicious it hurts. Since it was very much like a scene from a Bond flick, Smirnoff decided to think about her predicament as a secret agent officer might. This was something she

knew was not expected of her, but she couldn't believe that any normal procedure was in force there in the Hudson Trench.

After what seemed like an eternity, First Class Fung came to the Control Room with more orders. They read:

Deep Angel USS *Octopus*

Proceed to sublevel cave 9 in the LMDC 1101 *section.*

"Sublevel 9? Get me Huxtable," Smirnoff ordered, without hesitation.

Fung flew out of the Control Room and scampered to find Huxtable in the Wardroom.

"I need Mendoza down here too! All trainees out! This could be a difficult maneuver." The Commander was in full swing now; she felt exhilarated.

Huxtable shortly sauntered through the portal of the Control Room, a wry look on her face. This irritated Smirnoff, but she knew she needed the experience that Huxtable could offer. "At your service, Commander." With a swing of her hip, Huxtable was in.

"Huxtable, we have been ordered to enter sublevel 9: Do you have a read on this cave?"

"Commander, this cave appears to be a closed cave. Its location would lead me to speculate that the attacks of 9/11 caused considerable damage to the cavity. There is some space to maneuver, but it's extremely tight. The entrance is full of sludge from post-9/11 landslides."

"Where's Ski?" asked Smirnoff. "I need Ski! O – get me Ski!"

Ski entered with a sadistic air. "You rang, Commander?"

"Huxtable, give Ski the specs on sublevel cave 9. I want to know if we can blow our way in. Ashcraft – deter-

mine speed and depth potentials." Smirnoff's commands had a shrill but confident ring. "I'll expect a report in ten minutes."

Smirnoff, wanting to pace off some steam, stepped out of the Control Room and into the sub's main gangway. There, she encountered Drs. Rubsy and Licht, who were on their way back to the lab. They obviously thought that the coast was clear for them to return to their precious larvae. Smirnoff had to chuckle at the sight of the earnest scientists. Although they had been fully trained in combat, their hearts were just not in it, and anyway they really didn't know what was going on in the Control Room. She decided to go to the lab with them for a few minutes. There she found Dr. Childs, who looked like hell. Upon inquiry, Smirnoff discovered that she had been completely enthralled with the 100-year-old coral specimens and hadn't left the lab for hours. "It's phenomenal, they reproduced at a rate 1,776 times the norm. I've never seen anything like it!" Smirnoff shook her head in disbelief, in rhythm with Childs. She wished she could hang around and enjoy the lab's giddy collective mood, but she knew more pressing activities were awaiting her back in the Control Room.

Huxtable and Ski were waiting for her with their calculations, as was Ashcraft. After saluting Smirnoff, they sat down to run over details with their Commander. "Our situation is possible, but not pretty," smirked Ski.

Huxtable piped in, "It'll give you the hallelujah you're looking for."

Ashcraft, glancing toward heaven, gave the countdown on Maneuver Sequence 346.

"Ready, girls? Hit it!" A chorus of aye-ayes resounded

throughout the sub as the *Octopussy*'s crew began Sequence 346. Smirnoff thought the girls were being a little too loud but judged their enthusiasm vital. She too was caught up in the thrill, and secretly wondered if this would jeopardize her rank. She was acting on orders, she knew, but the whole affair somehow felt illegal. She felt trapped, manipulated. She considered her rogue interpretation of orders to be dangerously edgy, as commander ethics go. She hadn't, she realized, thought twice about her crew, the corals, or their safety.

"Supercavitational torpedo number one – armed and ready." Ski was tense; her voice sounded tight.

Solemnly, Smirnoff gave the order to fire. The sub rocked with a force that propelled the women back, then forward into their instrument panels. Huxtable's exquisitely tweezed eyebrow hit a sharp corner and starting bleeding like hell. Smirnoff pulled herself up to the periscope stand. The sub seemed to have come to a complete stop even though the speed indications showed forty miles per hour. "Pea soup, girls. We are stuck. In the muck. Fuck!"

The *Octopussy* was sinking, but slowly. She was suspended in sludge and would probably stay that way for a while.

"Supercavitational torpedo two – armed and ready," Ski advised.

"Fire torpedo two!" Smirnoff had no choice but to believe that the second supercavitational projectile would eventually create the momentum and vacuum they needed to get through. "Guess those fancy new steering fins aren't much use in these waters," she whispered under her breath.

"Supercavitational torpedo three – armed and

ready." Ski was on it. She and Huxtable anticipated that a multiple launch would be necessary. Without much hydrogen and oxygen available, the supercavitationals were operating at only half their capacity.

"Fire torpedo three!" Smirnoff was using all her mental powers now to will the *Octopussy* to her rightful position inside the cave.

Wall pressure indicators were off the charts, sending emergency alarms throughout the sub.

"Shit! More speed, Ashcraft! Set angle at up, twenty degrees." Smirnoff planned to incrementally change angle in concert with acceleration to force the *Octopussy* into the supercavitationals' measly bubble and catch its "drift."

With a loud sucking noise, the uss *Octopus* moved forward and safely into the tiny cave.

"Supercavitational torpedo four – armed and . . . aaargh!"

The sub gave another, totally unexpected lurch. "What the fuck! Ski! What the hell was that?" Smirnoff had fallen on her well-padded butt; she was struggling to get to her feet and back to the periscope stand.

"Commander, we can't hang on here! The cave is giving way!" Huxtable yelled hysterically.

"Ashcraft – advise!" Smirnoff was stalling; she felt she'd been duped by the overzealous Ski.

But before Ashcraft could respond, Smirnoff gave the command to fire torpedo number four.

Ashcraft quickly pulled the bowlines to full rise. With agonizing slowness the sub lifted to a virile eighty degrees, throwing everyone violently back. The *Octopussy* exploded from the clenching underwater melm; she

popped up like a cork in a bathtub.

Smirnoff regained position at the 'scope stand. She was breathing heavily, gasping for air. The 'scope was full of sludge but this made it easier to adjust to the intense light she was experiencing. "Hallelujah! Jesus! We are in the tub! The big bathtub! Fucking Ground Zero!"

"ooD O – open the hatches! All girls on deck!"

Smirnoff was the first out, of course. She stood surveying the site. Around her were millions of luminous, presumably toxic octocorals, floating amid ten or twelve disengaged cruise missiles.

Commander Smirnoff rubbed her eyes. She couldn't believe what she was seeing; she thought she might be experiencing hallucinations brought on by exposure to toxic coral spores. She'd read about similar experiences in underwater photographer M. Sandler's book. The coral formations seemed to be glowing pink, green, and red. They pulsed with pixilated life, as though they were responding to Commander Smirnoff's inner rhythms. They were adapting to the male, militaristic forms of the unmanned cruise missiles. Smirnoff found her thoughts drifting to her silently thrusting love-partner, Rien. She shook herself violently, as though to free herself from female urges unrelated to the mission at hand. The corals throbbed in synch with Smirnoff's unbidden desire. She watched in helpless fascination, on the brink of spontaneous orgasm as they rose . . . and rose.

Almost unbelievably, Commander Smirnoff felt a hand fondling her sumptuous buttocks. This brought her sharply back to Navy life. Who would dare grope the Commander, especially at such a critical juncture of whatever the hell was happening? She wheeled, ready to

order a flogging for all concerned.

"Surprise!" crowed an exuberant Dr. Rubsy. "We thought you might enjoy these babies, Captain. Hot stuff, huh?"

"Our little beauties," said Dr. Licht, struggling to control her flowing chestnut curls in the stiff salt breeze of New York Harbor. "They're doing just what their mommies told them to do. Up and up they go. Where they stop . . . well, it's up to them. And you."

"What? What the –" Commander Smirnoff struggled to regain her composure. Her cheeks were flushed, her nipples were shockingly (and very visibly) erect. Her legs felt wobbly; familiar contractions were starting in her uterus. All too soon, she knew, the waves of female sexual response would rock her like a hurricane. Too late to try to hold it back: "Oh my . . . oh my God," she moaned. "I'm . . . I'm gonna. . . ."

"Sorry we had to pull the fake mission dodge on you, Olga," Dr. Rubsy said. "But there was no other way."

"This really is a day for surprises, Cap'n Olga . . . or may I call you Orga? I mean, in light of present cir-*cum*-stances? Bring her up, please, Dr. Gray!" said Dr. Licht.

Commander Smirnoff had previously been unaware of Dr. Licht's smutty side. She thought a reprimand might be in order. The other members of her crew were not offended, though; Officers Ashcraft, O, and Ski seemed to be in a hurry to free her from her lab coat. Fung knelt at her feet, fumbled with the wool uniform trousers. Huxtable did the same for Dr. Rubsy; the sight seemed strangely, impossibly erotic to the preorgasmic Smirnoff. Meanwhile, behind them, the towers of coral rose, burgeoned, and blossomed into

being.

Puffing slightly, a sly grin on her face, Dr. Gray emerged from the dark innards of the *Octopussy*. In her arms was a nude woman: a strapping, fresh-fleshed, curvaceous woman! You really could have knocked Commander Smirnoff over with a feather at this point.

"We made her just for you, sir – ma'am! *Octopussy*'s main nuclear nerve center has been monitoring your sexwaves closely, down to the minute, I might say."

So the Admiralty knew about her and Rien! They'd been spying on even their most secretive and intimate lovemaking sessions. There might have been hidden video cameras in his quarters, for all she knew. For some reason, this possibility only excited Commander Smirnoff further. Sweet female lubrication coursed in a slow trickle down her marble thighs. Her knees shook, her labia clenched, her G-spot quivered to life. She knew she was about to experience a multiple orgasm that would register on Richter scales around the world.

"The supercaves were loaded with fast-breed octocoral spores, your Highness," said Dr. Rubsy. "A much more agreeable payload than the usual plutonium isotopes, don't you think? They gather and spawn according your most urgent female needs."

"That's why we took the liberty of creating Flesherina," said Dr. Gray. "She's a syn-coral conglomeration of all the choicest parts your crew has to offer: the perky tits of OOD Gina Ashcraft, the round buttocks of Yeowoman Fung, the superhuman clit of Officer Huxtable . . . I could go on. Feast your eyes, Captain. You know you want her."

"But . . . but –"

"Don't be shy, Cap," said Dr. Licht, nude now, emerging from the press of Navy womanhood that surrounded her. "Your fem-friendly sexual orientation is probably the worst-kept secret in naval history. Want me to show you how it's done?" With that, she fell upon the limp, yielding Michele Kelly, who tittered with delighted abandon.

Commander Smirnoff was awash in the first stages of full-body orgasm. The newly spawned Flesherina approached her slowly, an impossibly desirable female Frankenstein. As the two women came into contact with each other, the coral towers spontaneously rising behind them quivered with a joyous structural emotion. Breast pressed against breast; mound of Venus ground against mound of Venus . . . Smirnoff felt herself penetrated. By what, she couldn't tell, exactly. Not that it mattered.

The *Octopussy*'s iron deck was an orgiastic tableau. The masses of people gathered along the stricken city's shoreline cheered. Helicopters buzzing overhead broadcast triumphant music, filming the day's events for happy posterity. The setting sun cast the gleaming new coral towers – fully grown at well over 1,776 feet – in a cheerful, roseate glow. Dolphins leapt and laughed. Commander Smirnoff's eyes rolled back into her head as Flesherina's strong, capable hands palpated her breasts and buttocks. The half-human life-form's strange, super-hard coralline protuberance plunged ever deeper into Commander Olga's clenching molten core. "Rien," she cried, as she exploded into a climax of supernova proportions. "Oh, Rien! Rien!"

Notes on Contributors

COURTNEY LEE ADAMS JR. is a musician, writer, and activist living in New York City. She works with Code Pink New York and tutors at 826NYC. Her recent release *Know What I Mean?* is available on Olympic Records. For more information, go to www.courtneyleeadamsjr.com.

DANA BAUER is not a writer but an architist basking in the dark arts of sunny Los Angeles. Though the file will remain forever sealed, her criminal record has enjoyed some scattered activity. Today, her efforts are focused on conducting crime of the cultural variety.

NICK BRIGGS grew up in Whitby, North Yorkshire, England. He went to school in York. Apart from a short time working in a chocolate factory when he was eighteen, he has always been a photographer. He lives in London with his cat.

ROGER DUFFY's experience ranges from the design of office towers and airports to entire campuses and residential developments. Currently, Mr. Duffy is involved in the design of the Kuwait Police Academy as well as office and mixed-use developments in Dublin, Amsterdam, and Paris. In New York, he recently completed the award-winning design of 350 Madison Avenue and is currently involved in the renovation and restoration of the Helmsley Building at 230 Park Avenue.

Curator TARA HOWARD is co-founder of Preston Howard, a contemporary art consultancy. She lives in London, enjoys dressing like jailbait and smoking Cuban cigars. Her family motto is: *Noli me vocare, ego te vocabo.*

Notes on Contributors

MATTHEW LICHT is the author of the detective trilogy *World Without Cops* and the director of the underground classics *The Kerguelen of a Cartoonist*, *Snatcher At The Y*, and *Bean Dip/Bean Trip*. The soon-to-be underground classic *Kevin Kline And 1/2* will have its World Premiere this year.

KIT MCBRIDE has spent twenty-five years working in classic and foreign film distribution but is perhaps most known for her concise, brilliant, and scorching catalog descriptions for the paper plate and party goods industry. She has lectured and written on film for the past decade, establishing herself as a "mini-authority" on everything from burgeoning Asian Shock Cinema to the "roughies and nudies" of 1960's B (or DD) Hollywood fare. Film critic Roger Ebert once described McBride as having "metaphorically speaking, the largest breasts in Chicago." Producer Robert Evans (*Love Story*) vigorously disagreed.

The artist RITA MCBRIDE is considered one of the most charismatic "lab" directors in the world. Her efforts include a reconsideration of the "new knowledge of nature" and its cultural potential. She is currently a civil servant of Nordrhein-Westfalen, Germany, and resides in Cologne. She has brilliant irresistible blue eyes.

GEOFF NICHOLSON is the author of fourteen novels, including *Bleeding London*, *Footsucker,* and *The Hollywood Dodo*. His journalism has appeared in periodicals such as GQ, the *New York Times*, *Bookforum*, *Modern Painters*, *Street Machine,* and *Juggs*. He believes he is the

only contemporary English novelist to have been prosecuted for the crime of being "a pedestrian on a motorway." He currently divides his time between Los Angeles and rural East Anglia.

JACK PRETZER, a writer and performer, can often be found with his band Margina Legend creating music "specifically geared for gay serial killers." He can be seen in a brief appearance as a public bathroom pervert in the film *Rock 'n' Roll Frankenstein*. He is currently working on a novel about Las Vegas.

GORDON WALLACE – so mean he once shot a man just for snoring. Born in Romanza, California, he spent his childhood studying lumpen entomology. He has written comedy for TV and live performance, literary reviews, and his erotic short stories are widely published. His many ghost-writing personas have included stints as a geriatric ex-stripper sex columnist, an eighteen-year-old coed porn editrix, and a queer masturbation guru. He currently resides in New York City, and is editor of five gay monthlies. He can be reached at GTWALL@aol.com.

The Ways

Crimeways is the third of four Ways books conceived by Rita McBride. The Ways books – entitled *Heartways*, *Futureways*, *Crimeways*, and *Myways* – exploit and decipher genre writing with an entertaining and refreshing collective structure. The books include contributions from more than fifty artists, architects, writers, journalists, curators, and critics.

Heartways: The Exploits of Genny O
edited by Rita McBride and Erin Cosgrove
ISBN 1-55152-160-1

Futureways
edited by Rita McBride and Glen Rubsamen
ISBN 1-55152-172-5

Crimeways
edited by Rita McBride and Matthew Licht
ISBN 1-55152-173-3

Myways
edited by Rita McBride and David Gray
ISBN 1-55152-198-9
AVAILABLE 2005